IMAGES
of America

DEPEW

IMAGES
of America

DEPEW

Arthur J. Domino and Theresa L. Wolfe

ARCADIA
PUBLISHING

Published by Arcadia Publishing
Charleston, South Carolina

Printed in the United States of America

Library of Congress Control Number: 2014948119

For all general information, please contact Arcadia Publishing:
Telephone 843-853-2070
Fax 843-853-0044
E-mail sales@arcadiapublishing.com
For customer service and orders:
Toll-Free 1-888-313-2665

Visit us on the Internet at www.arcadiapublishing.com

*This book is dedicated to all of the hardworking
individuals past and present who have contributed
to making Depew the fine village it is today.*

CONTENTS

Acknowledgments 6

Introduction 7

1. Early Days 9

2. Industry 25

3. Transportation 41

4. Fire Department 67

5. Police Department 79

6. Churches 85

7. Schools 97

8. Clubs and Celebrations 113

ACKNOWLEDGMENTS

The authors wish to extend special thanks to Depew Village historian's intern Emily Henrich, senior history major at SUNY Brockport, for her knowledge of computers in preparing the layout for this book. Most of the photographs are from the Village of Depew historian's collection as well as the Lancaster Historical Society. Other images are identified as indicated in the appropriate captions. We have used information on the history of Depew as compiled by the late Daniel H. Idzik in the mid-1950s as well as previous historians and volunteers for the presently inactive Depew Historical Society. A special thank you to Alleyn Levee, landscape consultant and Olmsted scholar, who has provided the historian's office with copies of early maps of the village and correspondence relative to the early days of the village. And lastly, thanks to our acquisitions editor Sharon McAllister for her assistance and advice.

INTRODUCTION

It takes a man of vision and determination to build a community in the wilderness. It also helps if he has the money to fund his enterprise. Apollos Hitchcock was just such a man. A native of Connecticut, he had a number of successful business ventures behind him when he decided to invest in western New York. Before the century ended, other men like him would create the village of Depew on the same land.

When the Holland Land Company surveyors laid down the West Transit Line through their holdings in western New York in 1798, they created a road running north and south through New York State. A decade later, when they laid out the Buffalo Road running east and west across the transit line, they caught Hitchcock's attention. He bought his land along the road just west of the transit line. He chose his parcel well.

It was a heavily wooded area, including a largely flat, cleared meadow filled with wildflowers and crab apple trees. The site he chose for his house was an abandoned Indian encampment on a trail they still used to travel to the reservation. They called the place Jukdowaageh. Hitchcock soon had a prosperous farm, gristmill, and distillery, but few were willing to follow him into the wilds of western New York. The Town of Cheektowaga, New York, was finally formed in 1829, encompassing the Hitchcock lands. The east side of the transit line was incorporated as the Town of Lancaster in 1833.

The Buffalo & Attica Railroad crossed Transit Road in 1842, followed by the New York Central & Hudson River Railroad a decade later. When the New York, Lackawanna & Western and the New York, West Shore & Buffalo came in 1883, investors began to take notice. At no point in the country did the main trunk lines of four major railroads pass so close together. The flat, undeveloped land became very attractive. Cayuga and Scajaquada Creeks could supplement the supply of groundwater, but in time, that supply would prove entirely inadequate for the proposed metropolis of 30,000.

The Buffalo Land Company, the Depew Improvement Company, and the Bellevue Land Company began to acquire land in 1892 and cleared it for development.

The Depew Improvement Company engaged the services of the premier landscaping firm in the country. Olmsted, Olmsted & Eliot of Boston would design a whole village around a manufacturing theme, the first time the firm attempted such a project. They built the first house in April 1893, and before the end of the year, 16 more houses and 6,000 feet of sewers were added.

When the New York Central Railroad president Chauncey M. Depew announced in 1893 that he had purchased more than 100 acres for his locomotive and repair shops, the place became known as "the place where Depew will build." In 1894, this property was incorporated as the Village of Depew.

Development continued with the construction of other manufacturing facilities related to the railroad industry, including the Gould Coupler Company, Gould Storage Battery, Magnus Metal, Union Car Works, Buffalo Brass Works, and American Car and Foundry. Most passed into history

when the locomotive shops closed in 1931. Others continued in operation through World War II. The Gould Coupler Company was purchased by Dresser Industries in 1968 and continued in operation until it was shut down in 1986, just three years short of its centennial. It was the oldest continuous employer in Depew.

Responding to the growing need for water, the Depew and Lake Erie Water Company was incorporated on May 10, 1900, to provide water from Lake Erie to a reservoir and pump station to be located on the block west of Vanderbilt Avenue, just south of the Buffalo-Depew Boulevard and west of the Tonawanda branch of the Lehigh Railroad. The company would provide water for fire protection and also supply all of the industrial and residential areas of the village. Eventually, as the Depew and Lake Erie Water Company expanded to other communities, it would become an early form of the Erie County Water Authority.

To encourage development, the company donated land for the German Lutheran and SS. Peter and Paul and St. James Catholic Churches; the north side firehouse on Ellicott Road; Depew Village Park (Veterans Park); and the four-story YMCA building, which still stands today at the corner of Walden and Tyler Streets.

Original construction was focused south of the tracks, but with a change in management in 1895, attention was turned to the north side. First, Subdivision 3 was opened and improvements were made. The company headquarters were moved from the Water Works Building at Penora Street and Sawyer Avenue to a new structure at the corner of Transit and Ellicott Roads. The building would serve as a bank and community center; it was hinted that it would also serve as a village hall. The Depew Improvement Company, managed by the Russell brothers, was correct in that the development of the village would be to the north and west.

The Pfeil subdivision north of French Road and east of Transit Road was developed after World War II. This was followed by the Howard Builders, who built north and south of French Road and west of Transit Road. Marrano Brothers built their subdivision to the east of Transit Road and north of Columbia Avenue. Ferry Brothers built east of Marrano's subdivision and also north of Columbia, bounded by Warner Road.

In the early 1960s, the J.W. Clement Printing Company relocated from the city of Buffalo to the village of Depew, constructing a large printing plant as the centerpiece of the TC Industrial Park located on George Urban Boulevard west of the New York Central Railroad spur.

The growth in this area continued with the development of homes in the area west of the Clement plant to the village line at Dick Road and also north of George Urban Boulevard. The primary home builder in this area was Helenbrook Homes. This unparalleled growth led to formation of a sixth fire company to service this area in 1968, and a third fire station was constructed to house the company and its equipment.

In the 1960s, Ellicott Road was extended through the property that once housed the New York Central locomotive shops, and the thoroughfare was renamed Walden Avenue. This area was then slowly redeveloped commercially and continues to be developed today.

At the same time, there was also a shift in the commercial development in the village of Depew. The old area, as the Main Street section was called, was once a thriving commercial district with many mom-and-pop stores, taverns, and rooming houses, which succumbed to the new commercial development along Broadway, Transit Road, and George Urban Boulevard. The Depew Chamber of Commerce and the village board of trustees attempted to open up the Main Street area by extending Main Street through the Gould Coupler property in the late 1930s and again in 1941, but with the onset of World War II, production at the Gould Coupler facilities focused on war production, ending that idea. The heavy use of the automobile further added to the decline of the neighborhood shopping district, since people no longer had to rely on walking to do their shopping.

One

EARLY DAYS

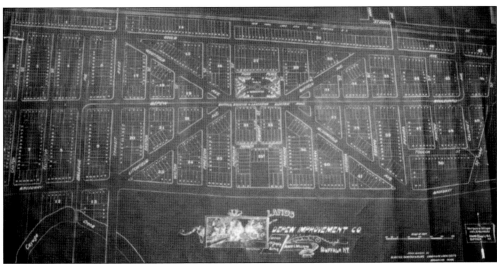

In 1892, the Depew Improvement Company hired the Boston firm of Olmsted, Olmsted & Eliot to design a whole village around a manufacturing theme, rather than just a residential area abutting a work center. This map shows the south side of the village and represents the village as it remains to the present day. The rest of the designed village never really materialized due to economics and other extenuating circumstances. (Courtesy of Aryley A. Levee.)

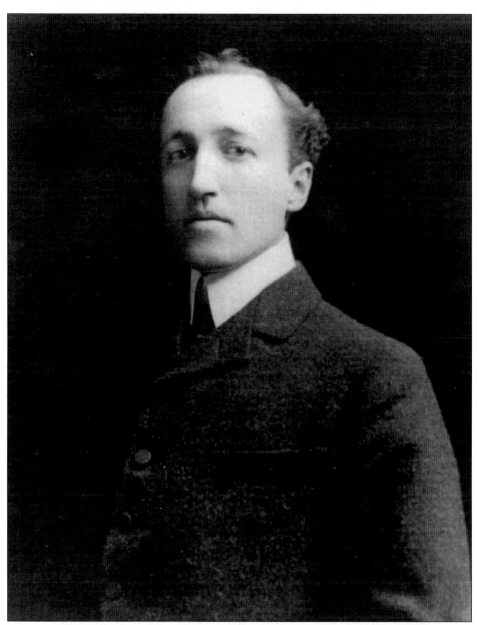

Chauncey Mitchell Depew never lived in the village that bears his name. He was born on April 23, 1834, in Peekskill, New York. After graduating from Yale in 1856, he studied law and was admitted to the bar in 1858. Entering politics in 1861, he won a seat in the New York State Legislature. He served as a member of the 18th Division of the New York State Militia in the Civil War. He was recognized by Commodore Cornelius Vanderbilt as a young man of outstanding ability. Leaving behind his political aspirations, he joined the railroad industry in 1866, continuing his connection to railroads until his retirement in 1921, having served as general counsel, vice president, president, and chairman of the board of the New York Central Railroad. A lifelong Republican, he held numerous appointed positions in government and was elected to the US Senate in 1899. Having attained great fame as an orator, he was invited to give the keynote address at the dedication of the Statue of Liberty. He died on April 5, 1928.

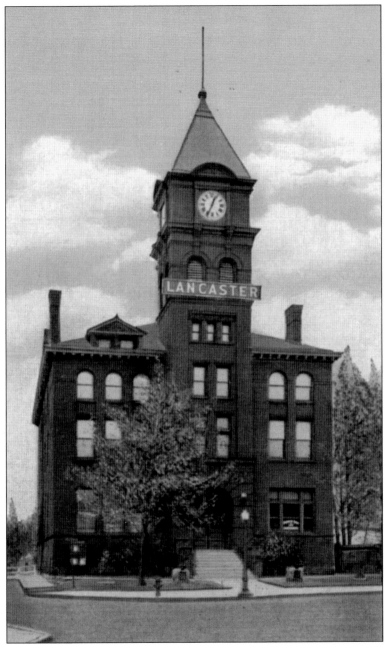

The Lancaster Town Hall served as the office of S. Jay O'Hart when he held the office of supervisor of the town from 1906 to 1914. He came to Depew in 1894, shortly after being admitted to the bar, the first attorney to settle in the proposed village. He drew up the incorporation papers for the village and failed by a small margin to become the first village president, becoming its first attorney instead, a post he held for more than 12 years. He was active in every civic and fraternal organization in existence in his time: most notably a charter member of the Depew Hook & Ladder Company No. 1 and first master of the Depew Lodge of Free and Accepted Masons. In time, he was eventually appointed village president. O'Hart was elected town supervisor again in 1925, but he died on November 20 of that year before he was able to take office.

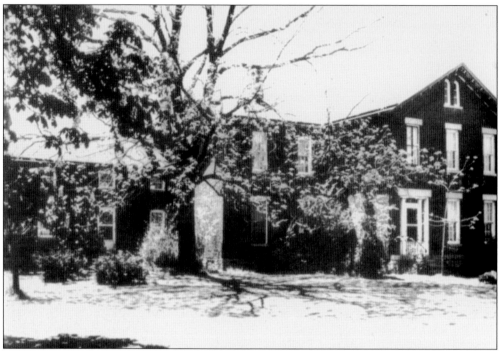

The Hitchcock House at the corner of Broadway and Borden Road was built between 1855 and 1860 by John Hitchcock. It took four and a half years to build since the brick and flagstone were hauled by ox team from Batavia and Medina, New York. This was probably one of the oldest homes in what was to become the village of Depew. The building fell into disrepair and was destroyed by fire in 1987. (Courtesy of Cheektowaga Historical Society.)

The incorporation papers for the Village of Depew were signed on July 23, 1894, in the Graney Building at the southwest corner of Transit Road and George Urban Boulevard. Owned by John Graney, who served as one of the first village trustees, it held the first post office in Depew, established on February 24, 1893. The building is currently occupied by a small business and apartments.

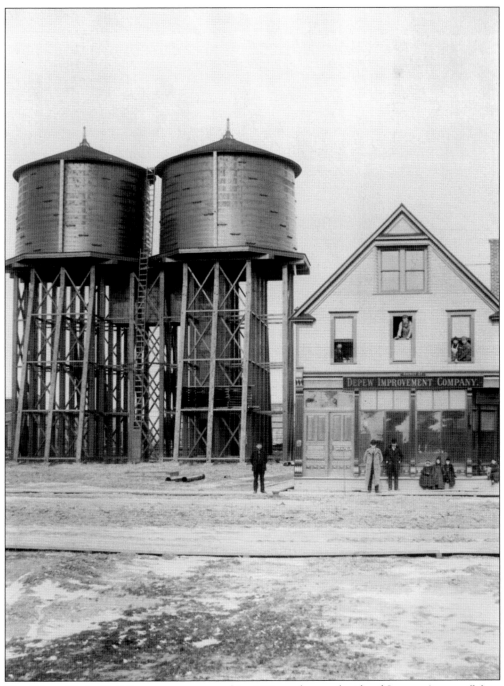

The Water Works Building was constructed in 1893 on the north side of Sawyer Avenue (Main Street) at Penora Street. It held the original offices of the Depew Improvement Company. In 1894, the building housed a temporary classroom for the school system and was also used as a meeting room for various organizations. The Depew Post Office also occupied the building from June 16, 1897, until August 1, 1906.

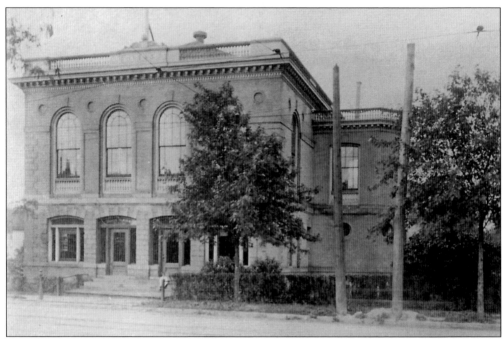

In 1896, the Depew Improvement Company, under new management, constructed a fine brick structure at the northeast corner of Transit and Ellicott Roads to serve as a bank building, offices, and a community center. It was hinted that the building would serve as the future location of the village hall. The bank closed in the early 1930s and became a restaurant until it was demolished in the early 1960s.

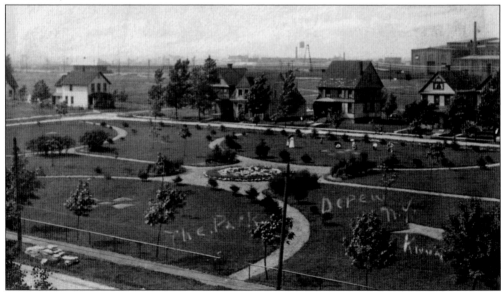

Early drawings by the firm of Olmsted, Olmsted & Eliot of Boston show an area designated for a park on Terrace Boulevard. Located between Park Place, Terrace Boulevard, Marengo, and Meridian Streets, it was completed by the first week in September 1898. The flower beds, trees, shrubbery, and footpaths with a fountain in the center made this the most attractive spot in the village of Depew.

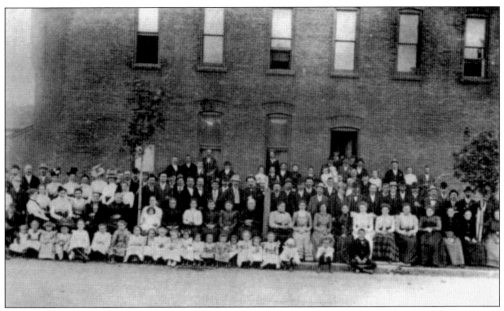

Weimers Hotel was built in the late 1890s at the southwest corner of Transit and Ellicott Roads and once was known as the Railroad Hotel. Many New York Central employees from the Depew Car Shops lived there. This photograph taken around 1900 shows the hotel residents and their families. This landmark building was later destroyed by fire on December 10, 1964.

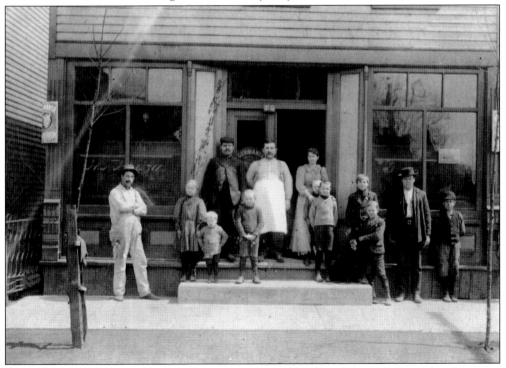

The H.F. Heyza Saloon at 72 Sawyer Avenue was one of as many as 15 saloons located on the street. This early-1900s photograph shows the owner, Hippalit Heyza, center, with his wife, Seweryn. Anna Heyza Zynda is the little girl second from the left. (Courtesy of Stanley Zynda.)

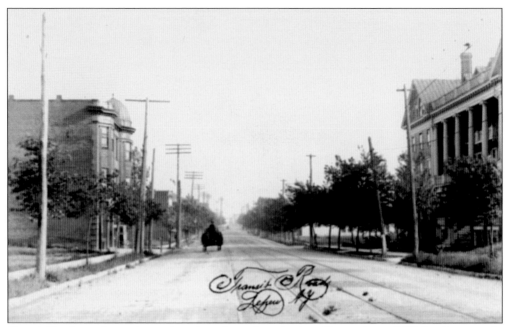

Transit Road was the main north and south roadway in the village prior to 1910. Looking south, the Depew Inn is in the right foreground, and the domed structure in the left foreground was the home and office of Dr. Daniel Stratton, who also served as a village trustee. The tracks of the Buffalo-Depew Electric Railway Company run down the middle of the road.

The Depew YMCA, located on Ellicott Road off Tyler Street, was opened in 1897. It had three stories. The first floor contained a parlor, game room, library, and office. The second floor housed the secretary and classrooms. The third floor was fitted for a gymnasium. When the YMCA was closed, the building was turned into apartments. It has been completely remodeled and is now occupied by the Dean Architectural Firm.

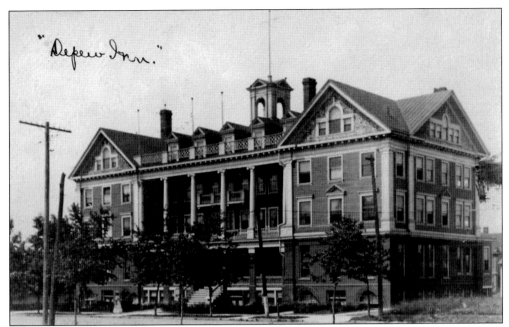

"Depew Inn"

From 1898 to 1910 at the northwest corner of Transit Road and Harvard Avenue stood one of the most magnificent buildings ever erected in the village of Depew. The Depew Inn was one of the showpieces of western New York and considered the best suburban hostelry in this part of the state at the time it was built. The building was finally destroyed by fire on June 25, 1910.

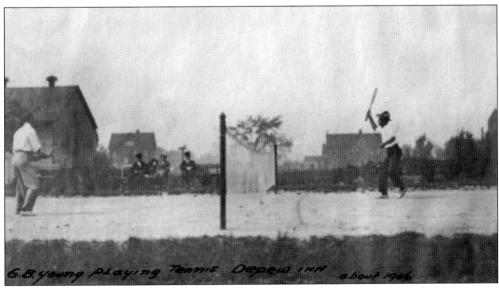

G.B. Young playing Tennis Depew Inn about 1906

In addition to providing temporary lodging for travelers, the Depew Inn served as a home for semipermanent residents waiting for their own buildings to be completed. It featured a large dining room, tennis courts, and black water baths. Provision was made for the storage of 200 bicycles, and a café served soft drinks for ladies who went out wheeling.

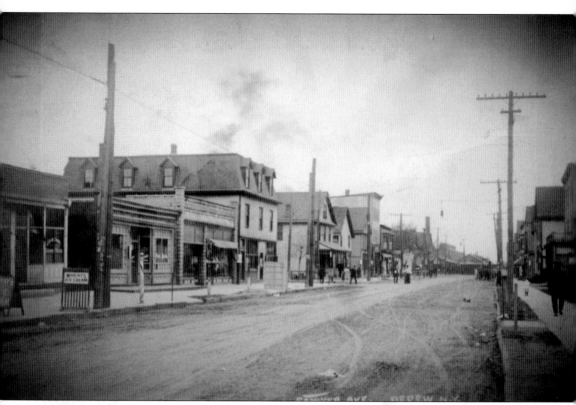

This is an early-1900 view of Sawyer Avenue facing west with the Gould Coupler Plant entrance at the end of the street. The numerous stores, restaurants, and shops made Sawyer Avenue a bustling business district. Muskingum Street intersects with the south side of Sawyer Avenue at the left center of the photograph.

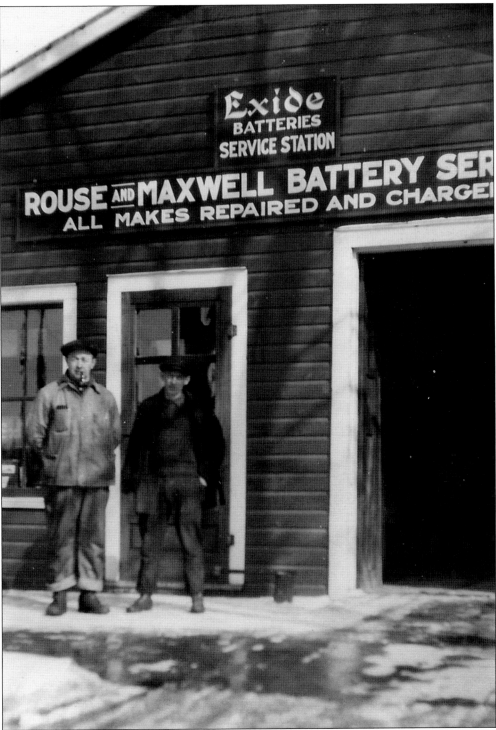

Rouse and Maxwell Battery Service was located on the east side of Transit Road near Ellicott Road. William Maxwell (left) and Silas Rouse (right), who operated the repair shop during the 1920s and 1930s, are pictured here in front of the station. Their motto was "A battery for every car."

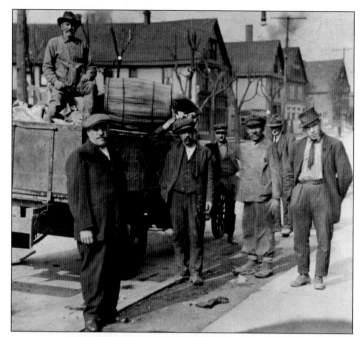

Pictured here is an unidentified crew from the Department of Streets in the village of Depew during the paving of Sawyer Avenue (Main Street) in the business district of the village. This crew evolved into the Depew Department of Public Works, which was charged with the responsibility of sanitation, sewer maintenance, snowplowing, and street paving.

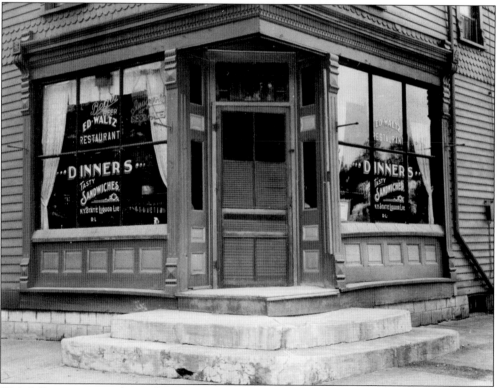

Waltz's Restaurant was located at the southeast corner of Transit Road and Ellicott Road. This photograph from around 1911 indicates that Edward Waltz was the proprietor. The Waltz family has early ties to the village, as George Waltz was one of the first village trustees and briefly served as village president in 1898. (Courtesy of Sheila Hynes Gibbs.)

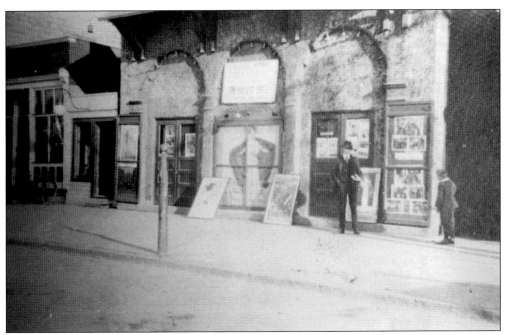

The Pastime Theatre, pictured here around 1915, was located on the north side of Sawyer Avenue between Muskingum and Sanilac Streets. It was built around 1908 by Harry Seeberg, who owned a clothing store and tailor shop next door. Manager Robert B. Albert became the owner of the Albert Theater when it was built in 1919 on Central Avenue in Lancaster, New York.

Walter F. Schultz, sales agent for the Rochester-based Zielinski and Lum Improvement Company, made his home and office at 59 Burlington Avenue. Appealing to many Polish immigrants, they offered to sell lots for homes and small farms on their tract in the town of Lancaster, outside of the village line.

In 1895, a change in management at the Depew Improvement Company brought the Russell brothers from Chicago. With 730 acres north of the tracks and 200 acres on the south side, they set out to expand to the north. They opened Subdivision 3 bounded by Transit Road, Olmstead Avenue, the Locomotive Works, and Ellicott Road. William and Gertrude Sanderson pose with their children at their family home at 56 Rumford Street.

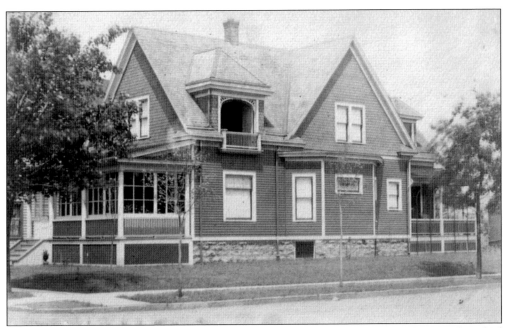

As development continued in Subdivision 3, larger homes like the H.M. Irwin Home on Rumford Street began to appear. The Russell brothers had unconsciously created a wall between the residents living on the south side of the tracks and those living on the north. Who lived on the wrong side of the tracks? The hard feelings they created lasted for years.

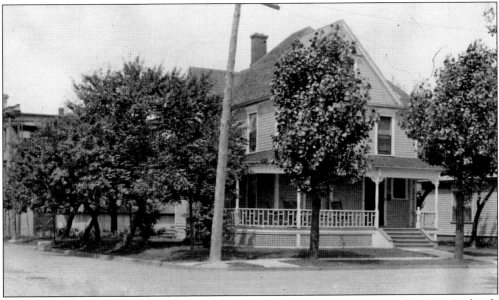

W.F. Richards was a department head at the Gould Coupler Works in the early 1900s. Richards chose to purchase a home on Tyler Street, where some of the most influential individuals in Depew chose to settle. The home of W.F. Richards clearly shows the amenities available to residents in this area of the village: wide streets, sidewalks, and all utilities.

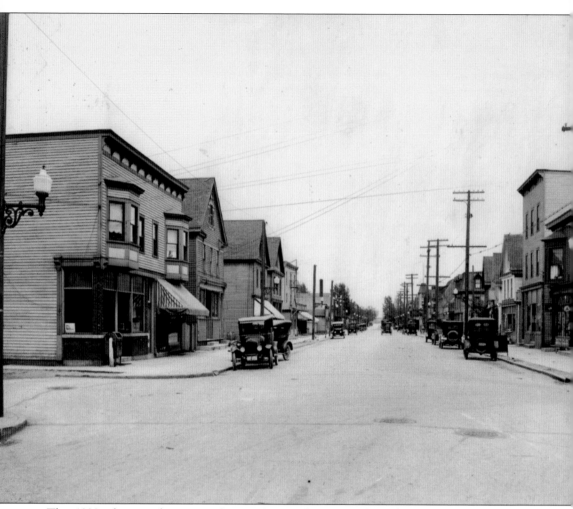

This 1920s photograph captures Sawyer Avenue facing east from the corner of Penora Street. With the advent of the automobile as a new method of transportation, the streets were paved to accommodate the large number of vehicles. Electric lights also lined both sides of the street for better vision at night.

Two

INDUSTRY

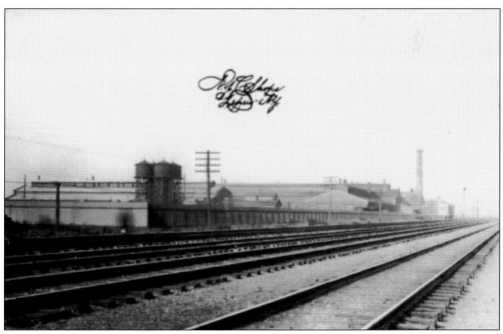

The New York Central Locomotive Works was located north of the New York Central Tracks with the buildings occupying more than five and a half acres, between Ellicott Place and the end of Ellicott Road at Lincoln Street. Ground was broken for the shop in May 1892, and it opened on April 1, 1893, with 40 employees. By 1895, the business employed 640 men.

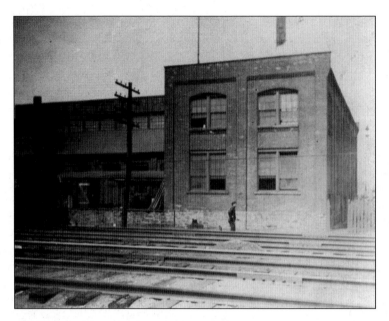

Magnus Metal, a division of the National Lead Company, was built in the late 1890s in the industrial complex on the south side of Ellicott Road, west of Transit Road. The plant manufactured brass and bronze bearings for the axles used on the railcars, which were phased out with the introduction of roller bearings. The plant still employed about 80 men in 1941.

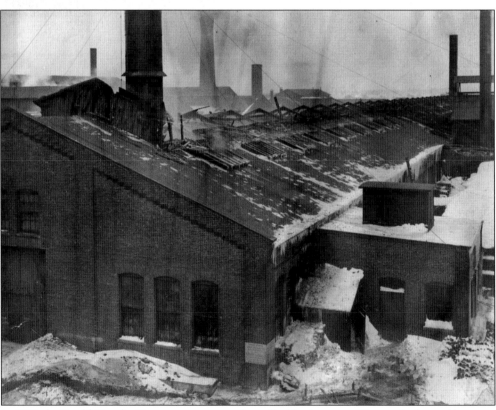

In 1892, the Gould Coupler Company constructed a malleable plant on a 60-acre plot located between the Delaware, Lackawanna & Western Railroad and the Erie Railroad, Neoga Street, and Transit Road. The cornerstone of the original Gould Malleable Plant, which still stands today, is inscribed with "These works were originated and perfected by Henry C. Gould during the year 1892."

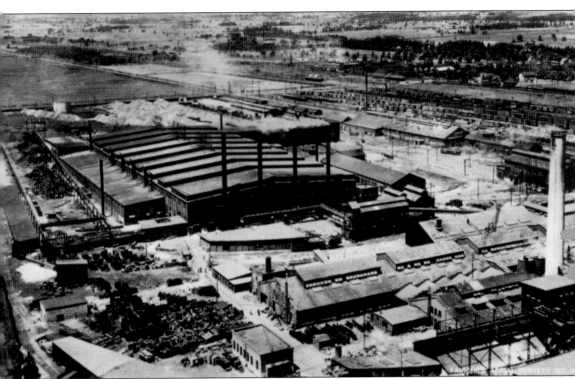

An early 1920s view of the Gould Coupler Company shows the original malleable foundry in the foreground. The steel foundry in the center was built in 1900. The four smokestacks were a sign of the four open hearth furnaces used in the production of the steel, which was poured into the molds to produce the steel castings for the railroad equipment.

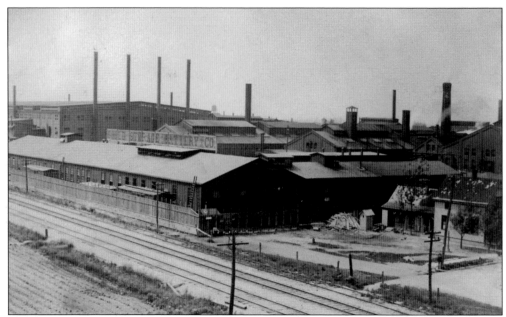

Gould Storage Battery Company was formed in 1899 as a division of the Gould Coupler Company to build storage batteries for use in the railroad industry. In 1930, the battery business was sold to the National Battery Company. During World War II, production turned to the manufacture of submarine batteries. The plant moved its operation out of the state in 1960, and the facility was eventually sold to Schuman Plastics.

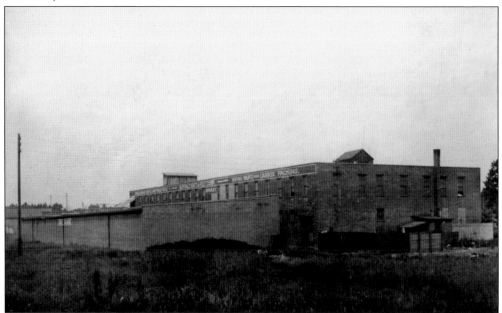

Buffalo Batt and Felt Corporation Depew Plant is located on the south side of Ellicott Road (Walden). The plant was built in 1910 by Loesser Bothers of Buffalo as a rag shop where rags were graded and reshipped. Later, numerous cotton-based products for mattresses, wiping waste, and packing were manufactured. The plant has survived many fires throughout the years, and it is now the oldest continuous employer in the village.

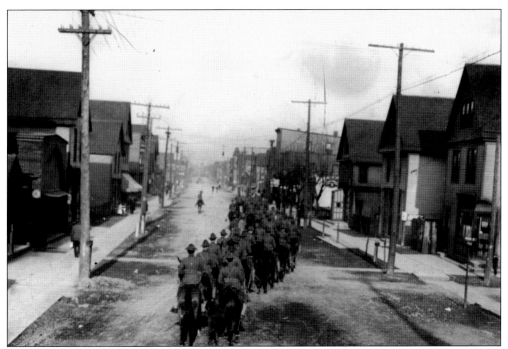

At the Gould Coupler Plant, 2,800 men went on strike in late March 1914. The company hired around 1,200 strikebreakers, and as a result, rioting broke out in the village. About 1,200 soldiers were brought in to enforce martial law. Pictured here, a mounted Army unit leaves the Gould Plant as the labor dispute was settled in April 1914.

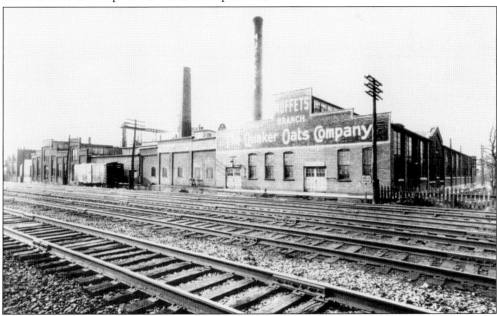

The Muffets Branch of the Quaker Oats Company was located on the north side of the New York Central Main Line facing Ellicott Road, part of the industrial complex that housed numerous other small manufacturing facilities primarily affiliated with the railroad industry. The plant shut down on April 1, 1971, after 40 years of operation.

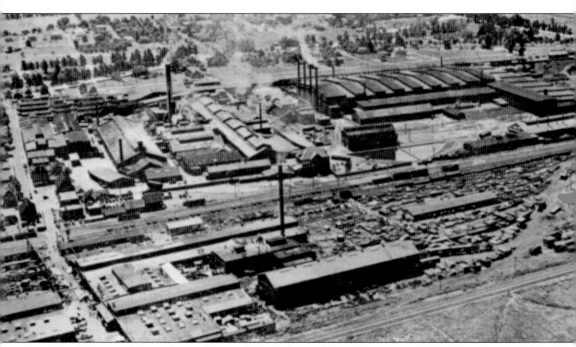

This 1930 aerial view shows the Gould Coupler and Gould Storage Battery Companies. The industrial complex in the foreground is that of the American Car and Foundry, which was located between the Delaware & Lackawanna Railroad to the south and the Lehigh Valley Railroad to the north. The plant manufactured railroad freight cars.

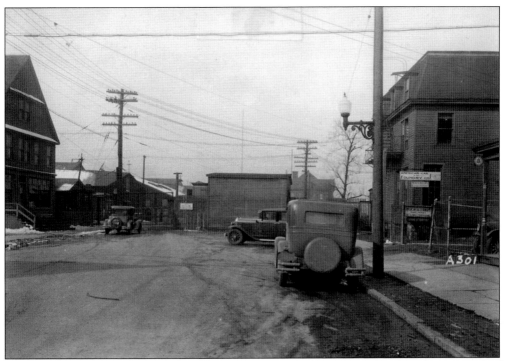

In 1930, the main entrance into the Gould Coupler complex was located at the west end of Sawyer Avenue. The American Car and Foundry Company Office is to the right. The building to the left, at the corner of Neoga Street and Sawyer Avenue, is one of 15 saloons located along Sawyer Avenue in this era.

The American Car and Foundry Company was located between the main line of the Delaware, Lackawanna & Western Railroad and the Lehigh Valley east of Transit Road. It turned to war production during World War I. The employees shown here are in the process of finishing bomb casings for the war effort.

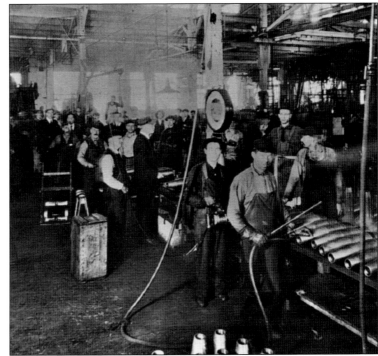

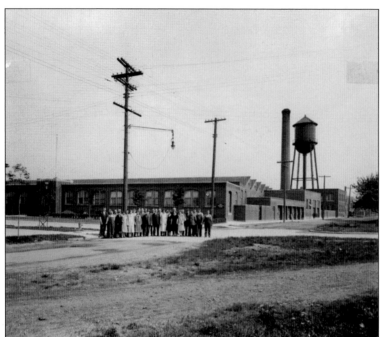

While most industry in the village of Depew was kept north of the Erie Railroad tracks, an exception was the Albert, Gooden, Beden Silk Mill, which was built in 1917 on the north side of Terrace Boulevard between Sanilac and Calumet Streets. This mid-1920s photograph shows the employees of the facility.

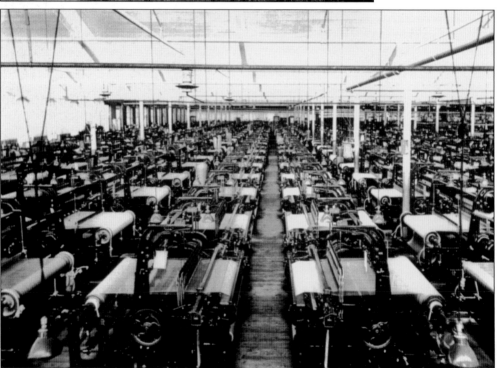

An interior view of the Albert, Gooden, Beden Silk Mill shows the silk weaving machinery. Silk was important for a variety of uses: as clothing, silk-screen printing, and filtration for food, pharmaceuticals, and chemicals. By the 1950s, silk weaving ceased, and the plant was converted by Duo-Temp Corporation to assemble aluminum-framed storm doors and window screens. Currently, the building serves multiple uses.

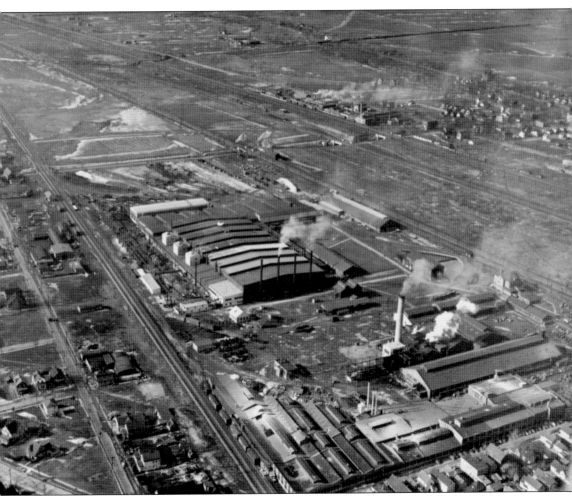

This 1942 view of the National Battery and Gould Coupler complex is an indication of the north and west sections of the village, which were yet to be developed. Following the end of World War II, this area became the prime location for residential, commercial, and industrial development, which had been predicted by the early developers of the village.

In 1942, the Symington-Gould Plant D Building was constructed on the Gould Coupler complex as a part of the war effort during World War II. The primary use of the building was to manufacture armor steel castings for the US Army and Navy. The building to the center left was a new powerhouse constructed to provide the additional power required for the increased production.

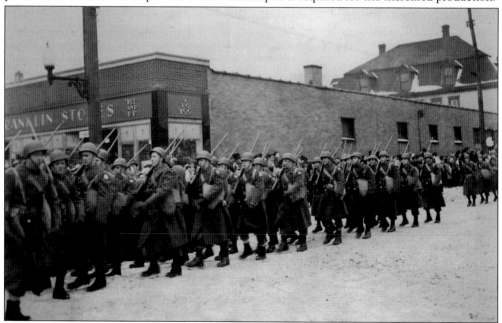

A military contingent at the corner of Penora and Main Street paraded to the opening of the newly built Plant D Building on the Symington-Gould property in early March 1942. The military presence was significant due to the increased demand for materials to support the war efforts during World War II.

One of the first labor management committees in the Buffalo area was organized at the Symington-Gould Plant in Depew after the construction of Plant D, when 90 percent of the plant's output consisted of war materials. The labor management committee was instrumental in overcoming any and all production problems faced with the changeover from railroad products to war materials.

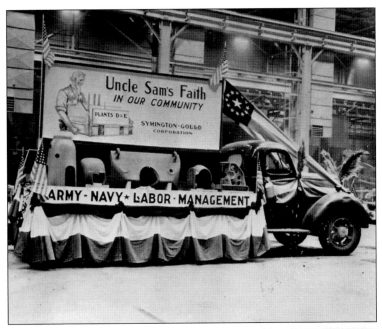

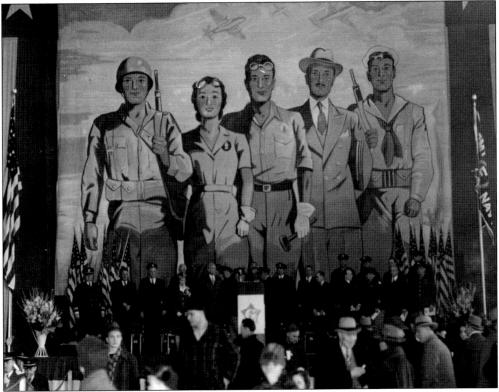

Behind the officials on stage at the Army-Navy E Award presentation is a poster that depicts the significance of the Army-Navy Labor Management Committee. The soldier and sailor represent the Army and Navy, the figure in the suit represents management, and the male and female workers represent the labor force.

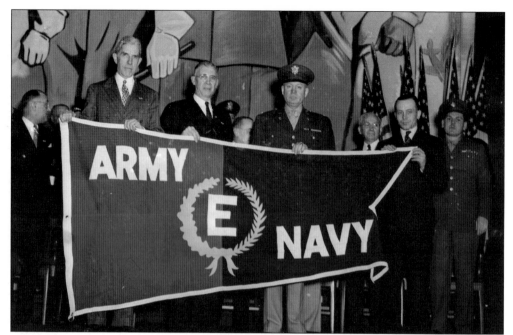

The Army-Navy E Award was formally presented to the Gould Coupler Works of the Symington-Gould Corporation on March 4, 1944. The Army-Navy E was the highest award for industries engaged in war work. Cpl. Desmond Derkovitz (far right), a wounded veteran, took part in the ceremony. He was a company employee prior to joining the armed forces in February 1941.

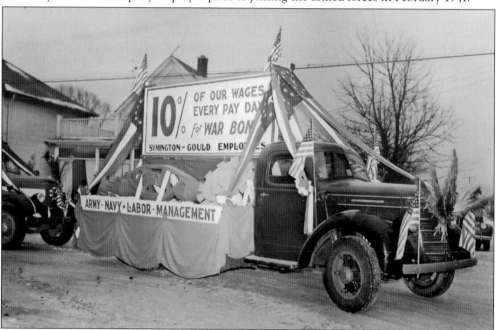

The Army-Navy Labor Management Committee, in addition to its efforts to promote cooperation between labor and management, also inspired all Symington-Gould employees to support the war effort by pledging 10 percent of wages earned every pay period toward the purchase of war bonds. Altogether, the employees and executives pledged $200,000 during the drive in 1944.

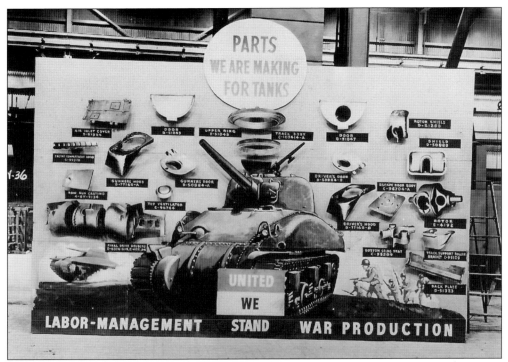

A display by the Army-Navy Labor Management Committee in 1942 represented all of the armor steel parts that were being cast in the new Plant D Building at Symington-Gould. Additionally, other castings for antiaircraft guns, bombs, landing craft, naval guns, and other ordnance equipment were manufactured in the plant.

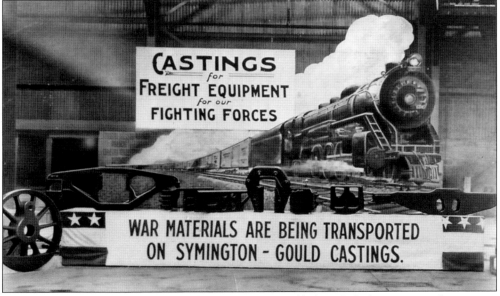

In 1942, the production of castings at the Symington-Gould plant shifted to armor steel in support of fighting forces overseas. About 10 percent of the company's manufacturing output continued in the production of steel castings for freight equipment that was to be used in the transportation of the war materials.

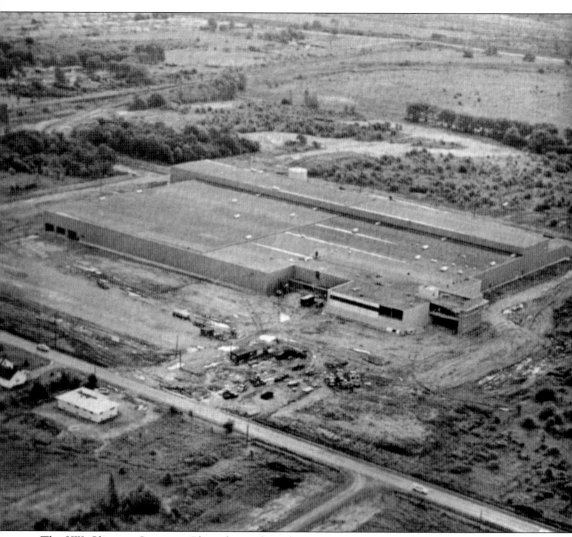

The J.W. Clement Company Plant, located on the south side of George Urban Boulevard west of the New York Central Spur, was under construction on July 21, 1962. The plant was the centerpiece of the 150-acre TC Industrial Park. A number of the facilities were ancillary to the J.W. Clement Company.

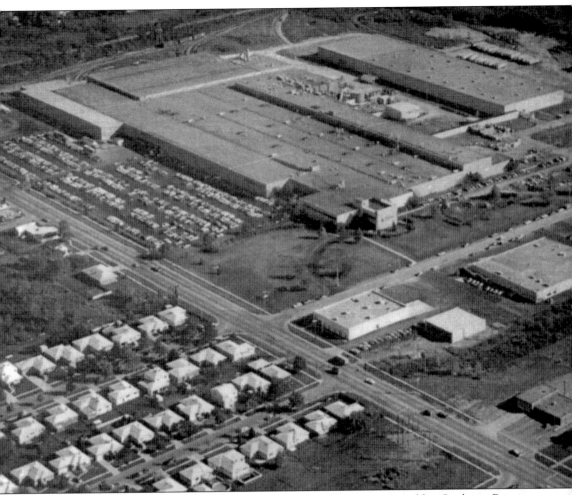

In 1965, J.W. Clement became Arcata Graphics, and in 1993, Arcata was sold to Quebecor Printing, a Canadian company. The Depew plant continued its production of high-profile publications and paperback books into the early 2000s. In 2005, the plant was the largest producer of paperback books in the world, but it closed in December 2011.

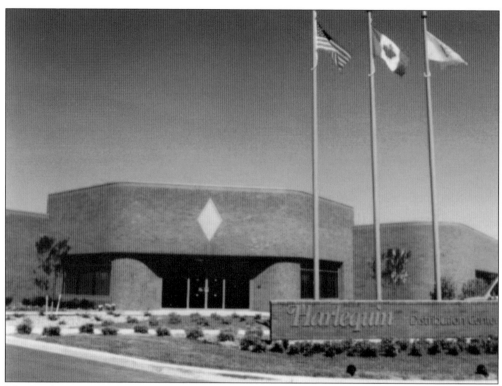

The Harlequin Distribution Center is a 400,000-square-foot facility located on the north side of Walden Avenue, east of Dick Road. It is one of the world's leading publishers of books for women, publishing more than 110 titles a month in 34 languages and shipping over 100 million books per year.

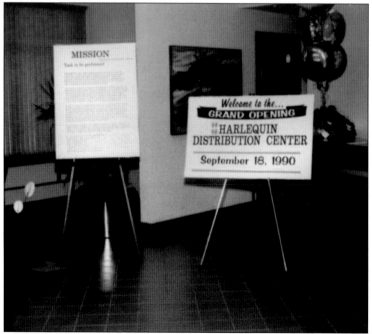

The Harlequin Distribution Center held a grand opening of its facilities on September 18, 1990. In the ribbon-cutting ceremony, Depew mayor Arthur J. Domino wielded the scissors, assisted by Harlequin executives and New York State assemblyman Paul Tokasz. In time, Harlequin would serve 110 international markets on 6 continents.

Three

TRANSPORTATION

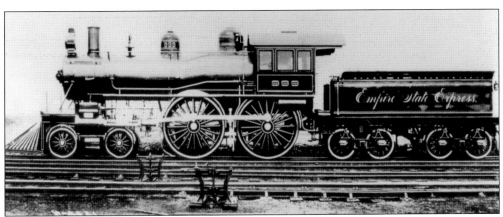

New York Central Locomotive 999 and locomotive engineer Charlie Hogan achieved a long-standing world speed record on May 10, 1893, pulling the Empire State Express at 112.5 miles per hour between Batavia and Depew. Designed and built in 1893, the locomotive was serviced at the New York Central locomotive shops where Walden Avenue now bisects the property between Lincoln Street and Ellicott Place.

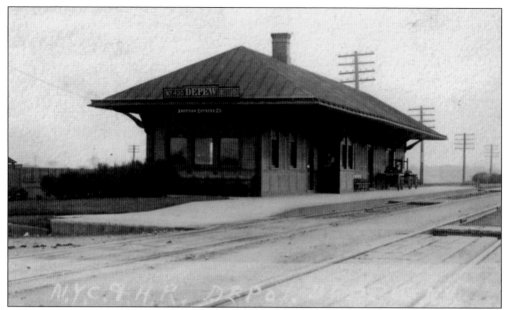

The Depew Station of the New York Central Railroad line was first established here about 1893 on the north side of the main line off Ellicott Road east of Transit Road. The station was enlarged in 1900 to nearly double its former capacity. It measured 96 feet by 18 feet and included a ladies' waiting room, gentlemen's waiting room, ticket office, express office, baggage room, and a large freight room.

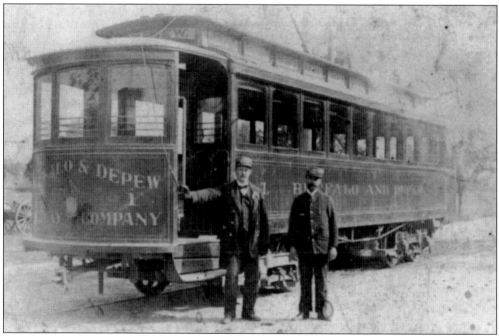

The Buffalo-Depew Electric Railway Company was incorporated on May 7, 1897. The purpose of the company was the construction of seven and a half miles of double track from the Buffalo city line on Genesee Street to Ellicott Road in the town of Lancaster, passing through the north side of Depew. The powerhouse of the company was located on the Buffalo-Depew Boulevard.

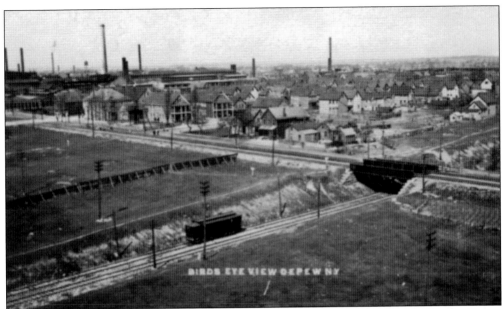

The streetcar on the Depew loop of the Bellevue & Lancaster Railway is shown on Sanilac Street, where it passes under the main line of the Erie Railroad. The fare of 7¢ would pay for a one-way trip to the Buffalo city line, which took 22 minutes.

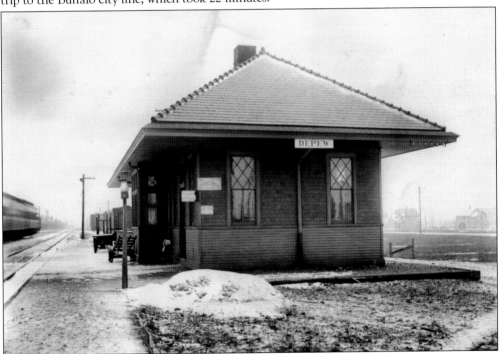

In 1901, the Erie Railroad depot was built on Erie Place at the north side of Gould Avenue along the main line tracks just to the east of Transit Road. Five eastbound and five westbound trains stopped at the station daily to service passengers and freight. After it was closed in the 1950s, it was used as a warehouse; it was later abandoned, vandalized, and finally destroyed by fire in the late 1970s.

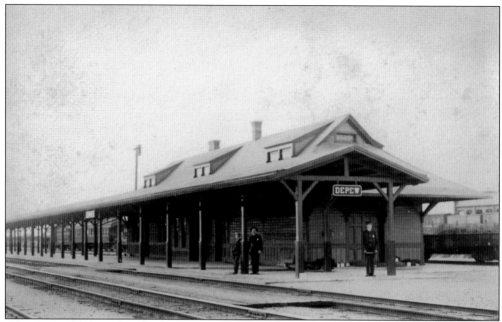

The Lehigh Valley Railroad depot was located on the west side of Transit Road between the Lehigh main line and the New York Central main line at the Niagara Junction, where the Lehigh east and west main line split and connected to a branch line of the Lehigh that ran north to Niagara Falls.

The Buffalo-Depew Amtrak Train Station is located on the east side of Dick Road between Walden Avenue and Broadway on the southern side of the CSX Railroad main line. The station was completed in 1979, but prior to its construction, several mobile trailers were used to accommodate passengers until building was completed.

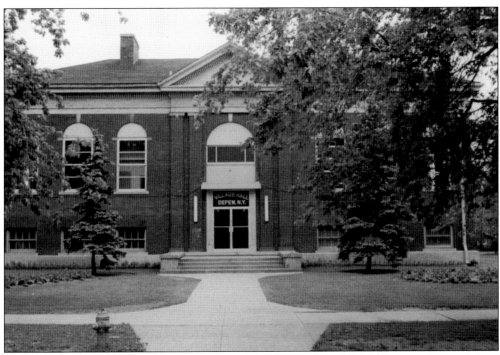

The original village hall on Terrace Boulevard was designed in 1913 by Harris and Merrith and built by Meyer and Meyer. Alexander Utecht did the carpentry. It was dedicated on June 18, 1914. The original design called for council chambers, a police court, clerk's office, engineer's office, attorney's room, vault, and an auditorium with a seating capacity for 500. A jail, kitchen, and dining room were in the basement of the building.

In 1919, Alexander Utecht built the Bank of Depew on Main Street next door to the Colonial Theatre. The bank closed during the Great Depression. Subsequently, the bank was taken over by the Marine Trust Company, which operated a bank at that location until its move to the D&L Plaza. The building is currently occupied by the Chosen Few Motorcycle Club.

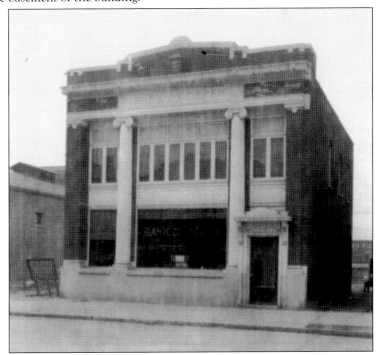

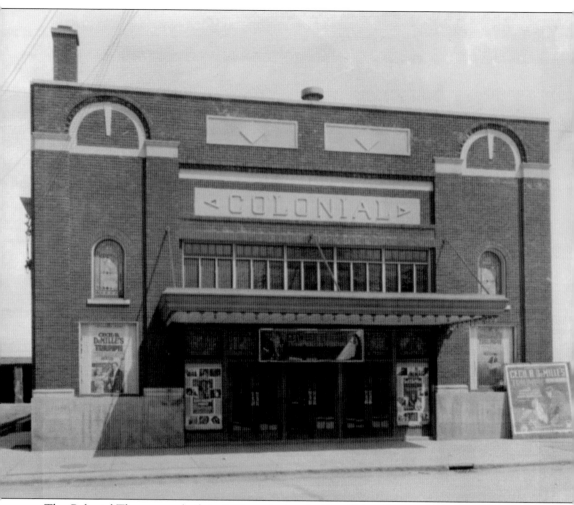

The Colonial Theatre was built in 1919 on the north side of Main Street adjacent to the Bank of Depew. The building was constructed by Alexander Utecht, who built many landmark buildings in the area. The theater closed in the 1960s and was then used for other purposes until it was demolished in 2013.

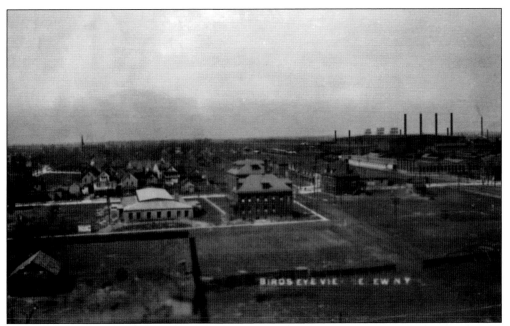

This pre-1921 bird's-eye view of the south side of Depew shows St. Augustine's Church and convent in the left foreground with St. Augustine's Parochial School in the background. The Gould Battery Company and Gould Coupler Foundry buildings are in the background of the photograph.

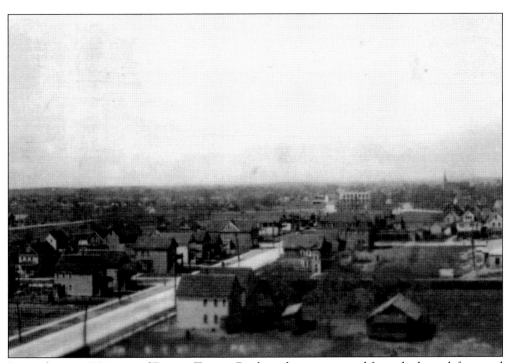

In another pre-1921 view of Depew, Terrace Boulevard runs westward from the lower left toward the center of the image, and Penora Street crosses at the center. The multistory building in the background is the newly built Depew High School.

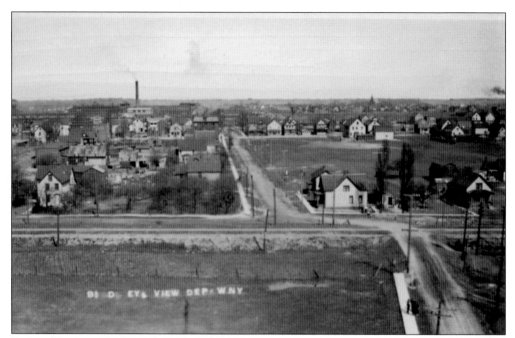

Pictured here is a look north, with Calumet Street crossing the main line of the Erie Railroad. At right center is Renova Park, bounded by Calumet Street on the west and Laverack Street on the north. Most of the baseball and football games of the era were played on this field.

This early aerial view of the north side shows the area referred to by many as "Goose Town," as many of the early residents raised geese. At left of center, the building with the steeple is the SS. Peter and Paul Church on the north side of Burlington Avenue.

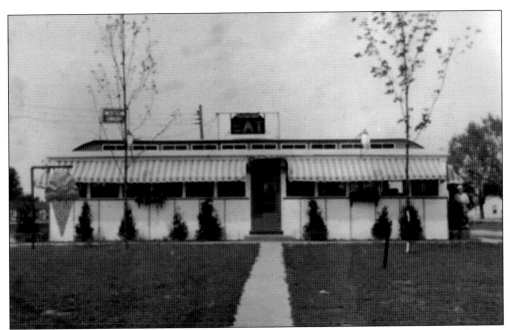

Five Point Diner, operated by Clara Hess, was located at the intersection of Litchfield Street with Transit Road and Broadway. Prior to the construction of the New York State Thruway, US Route 20 was the major east-west highway from Boston, Massachusetts, to Oregon. The diner was a landmark on the route and a stopping point for many travelers. It was demolished in 1973 and replaced by a Burger King restaurant. (Courtesy of Carol Wawrzyniak.)

In 1920, the Depew Post Office was moved from its north side location to the northeast corner of Penora Street and Sawyer Avenue (Main Street). The postal employees in the photograph are, from left to right, carriers Leonard McHugh, Julius Topor, Joseph Keefe, and John "Brickey" Knab (in the doorway). The building also housed Rejewski's Hardware store.

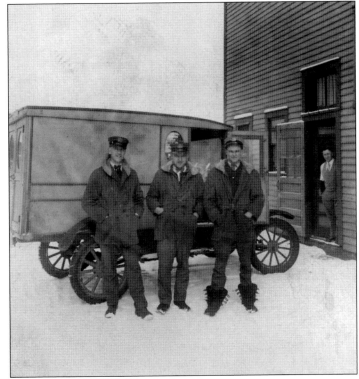

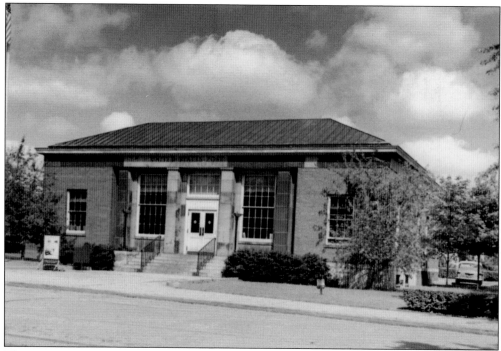

The present Depew Post Office was built on Warsaw Street between Suffield Street and Terrace Boulevard after the site was selected on January 1, 1938. Through the efforts of Congressman Alfred Beiter, Mayor Arthur Prestine, and postmaster Joseph English, funding was secured. Designated a first class post office on July 1, 1949, the US Post Office at Depew, New York, was listed in the National Registry of Historic Places in 1988.

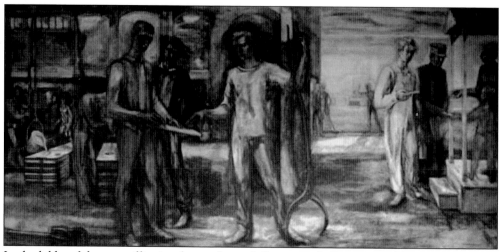

In the lobby of the post office is a featured mural, *Beginning the Day*, painted by the artist Anne Poor in 1941 under the auspices of the Treasury Department's section of fine arts. The Depew mural is one of hundreds commissioned by the government during the Depression that depicts contemporary life and local history.

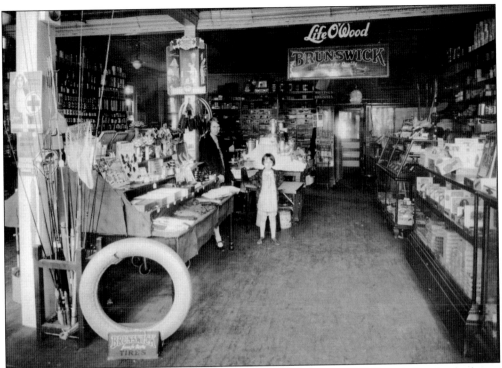

Pictured here is an interior view of Sharick's Hardware Store at 5785 Transit Road, which was located between Walden Avenue and Eliot Street. Norman W. Sharick purchased the business from Albert Sturm in the early 1930s. Elsie Sharick, left, and her daughter Mildred Sharick Whittaker, right, are shown in the newly acquired business.

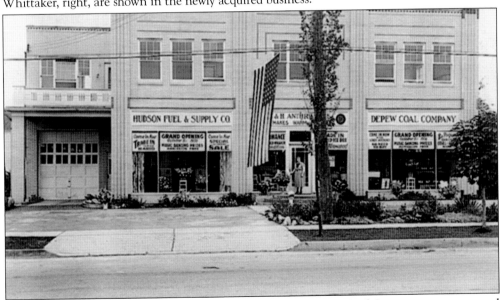

The structure housing the Hudson Fuel & Supply Co. and the Depew Coal Company was constructed by the Anthony Floss family at the southeast corner of Warsaw Street and Broadway, with a grand opening on October 5, 1936. In the 1950s, the occupancy changed to a lounge and restaurant, and today it is home to Magruder's Restaurant and Pub. (Courtesy of Matt Dombrowski.)

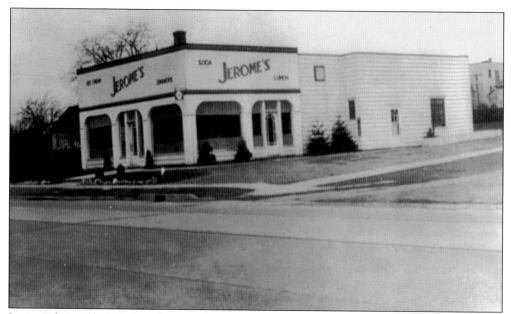

Jerome's, located at 4978 Broadway at Warsaw Street, was an ice cream and soda bar that also served lunches and dinners in the late 1930s and 1940s. It catered to teenagers, as it was located around the block from Depew High School on Terrace Boulevard. (Courtesy of Matt Dombrowski.)

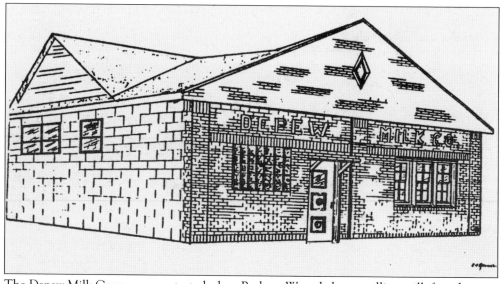

The Depew Milk Company was started when Barbara Wargala began selling milk from her two cows to neighbors. When the pasteurization law came into effect, she and her husband, Stanley, formed the Depew Milk Company and built this brick structure at 488 Gould Avenue in 1925. The business continues today as the Pep Dairy, operated by grandson Edward H. Wargala. (Sketch by Edward Adamski.)

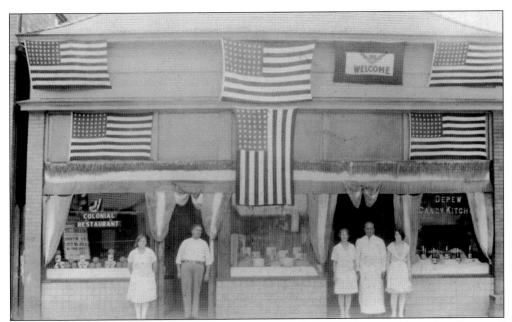

The Colonial Restaurant and the Depew Candy Kitchen were typical mom-and-pop, locally owned businesses on the south side of Main Street midway between Laverack and Sanilac Streets. The welcome sign and flags were on display to welcome visiting firemen during the 1928 Western New York Volunteer Firemen's Convention.

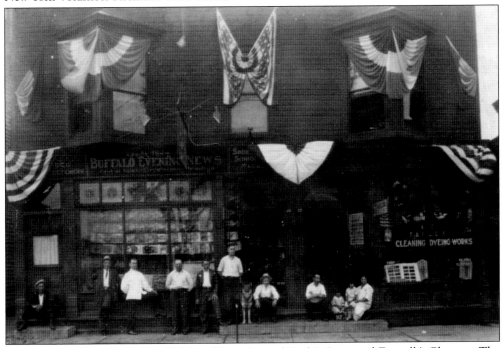

The Weiss Building, located at 39 Main Street, housed Pauly's Store and Zuppelli's Cleaners. The tenants posed for the Western New York Volunteer Firemen's Convention photographer in 1928. Pictured from left to right are Peter Baker, unidentified, Joe Mroz, M. Wielkiewicz, Adam "Spike" Jastrzembski, Lester Pauly, Jack (the dog), unidentified, and Mr. and Mrs. Zuppelli and family.

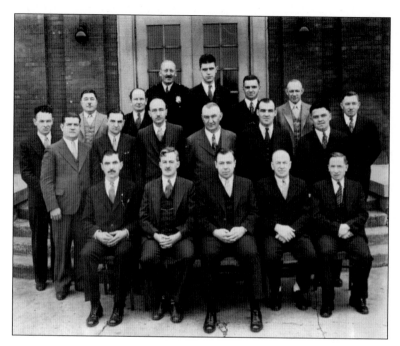

Depew Village board members and department heads posed in 1934 on the steps of the village hall on Terrace Boulevard. Mayor Arthur Prestine, seated third from the left, served as mayor from 1933 to 1942, leading the village from insolvency caused by the Great Depression. Mayor Prestine said when he was first elected to be mayor, no one wanted the job, as the village was broke.

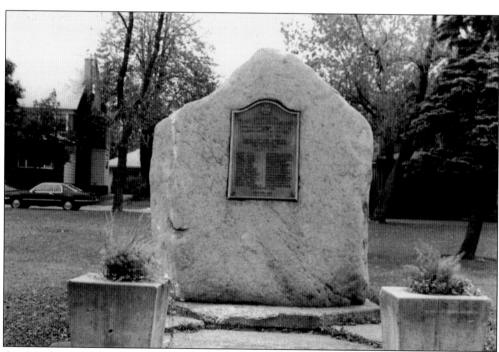

On October 29, 1939, the village green on Terrace Boulevard and Park Place between Meridian and Marengo Streets was formally named Veterans Park. A VFW War Monument was dedicated by various political and veterans' service organizations. The boulder was secured and set in place by Twin Village Post 463 VFW. The names of men from Depew and Lancaster who gave their lives in World War I are inscribed on a plaque.

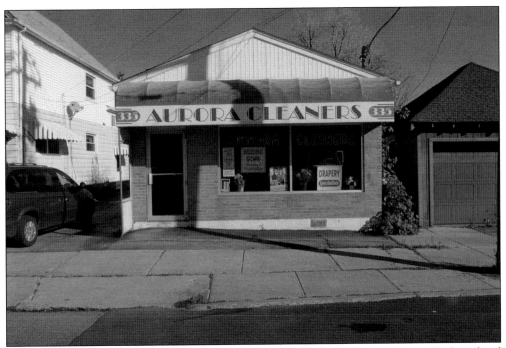

Aurora Cleaners, owned by the Forys family since 1939, was first located at 180 Terrace Boulevard and Kokomo Street. In 1947, a new store and shop was built at 335 Penora Street just north of Broadway, and it has been in continuous operation ever since. In the 1980s, after 40 years of dedication to his work, John Forys retired and sold the business to his brother Edwin and son Gerald.

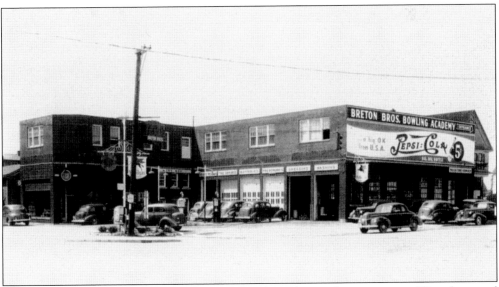

Pictured here in the 1940s, this building, located on the northwest corner of Broadway and Transit Road, housed Breton Brothers Garage on the first floor and a four-lane bowling alley on the upper level. P&K Pontiac Dealership later occupied the lower level. The building continues to serve as an automobile service facility.

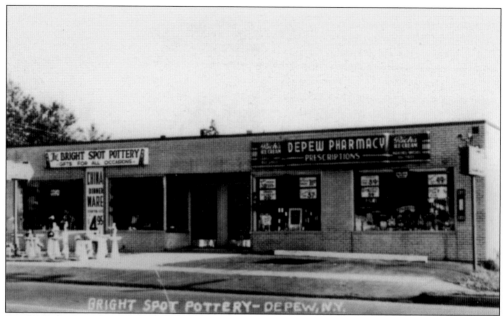

Bright Spot Pottery and the Depew Pharmacy occupied the building at 4911 Broadway at the southwest corner of Elmwood Avenue and Broadway during the late 1940s and early 1950s. After the pharmacy closed, Bright Spot Pottery then occupied the entire building until it closed in 2001, when the owner, Leonard Thrun, retired after more than 50 years in the business. Today, it houses the Depew Deli and Grocery.

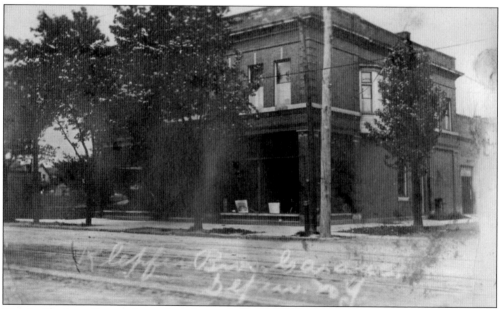

Klepfer Brothers Garage, located at the southwest corner of Transit Road and Harvard Avenue, was originally used to build and sell bicycles; it was followed by an automotive sales and service facility. In the 1940s, Farmer Brown, Inc., a packer of fresh vegetables in cellophane bags, occupied the building until a fire in 1971 caused them to close the business.

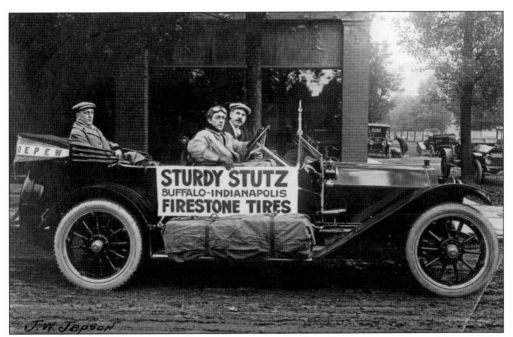

In the early 1900s, Klepfer Brothers Garage converted from building and selling bicycles to selling and servicing automobiles. Seated in the Sturdy Stutz are, from left to right, Dr. Daniel Stratton, a local physician who also served on the village board; the driver, J.W. Jepson; and Frank Klepfer (one of the Klepfer brothers).

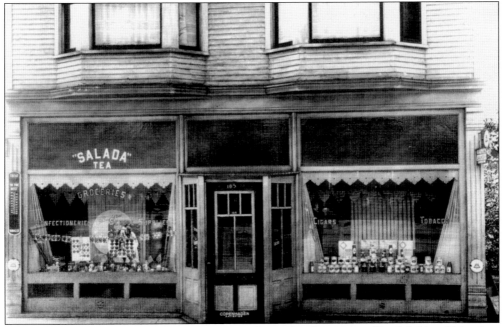

Bednark's Grocery and Confectionery Store was located at the corner of Litchfield and Meridian Streets. This was one of many typical mom-and-pop stores located in the village. It was owned and operated by the Casimer Bednark family. Just steps from the Depew High School, it was a popular shopping place for students during the lunch hour and after school.

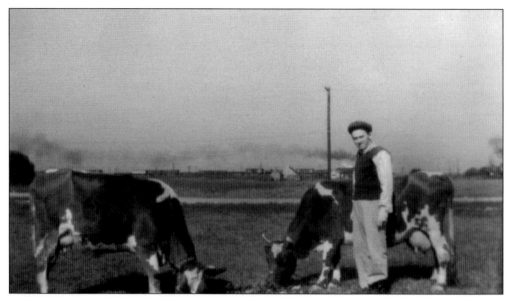

In 1946, this pastoral scene of Karol Unicki tending cows was taken near Terrace Boulevard, seen in the background, where Lackawanna Street is now located. The steam locomotive pulling the freight train eastward is on the Erie Railroad main line, and the area next to the railroad is today the site of the Depew Ice Rink and Firemen's Park. (Courtesy of Walter Gnorek.)

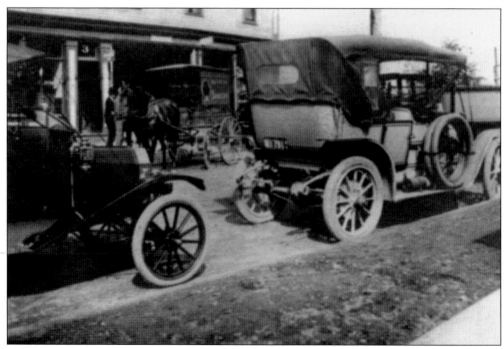

Bakeries were a thriving commercial enterprise in the early days of the village. A number of family-owned businesses operated retail stores and also made deliveries to local homes and other businesses. This horse-drawn wagon delivered baked goods such as bread and pastries to both the village of Depew and nearby Lancaster.

Pictured here in 1939, the D&L Bakery at 424 Penora Street between Gould Avenue and Terrace Boulevard is currently run by the fourth generation of the Geleszinski (Geles) family. The bakery is at the rear of the retail store. It also supplies a retail store at the Broadway Market as well as several restaurants and caterers in the area. (Courtesy of Mary Ann Geles.)

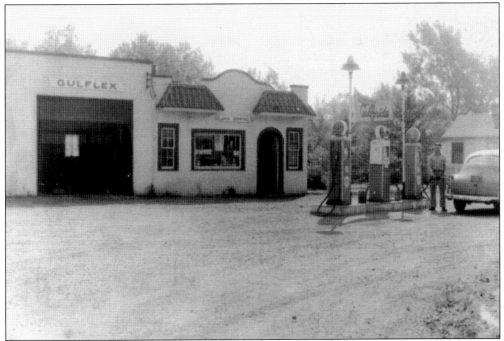

The Gulf gas station was located on the east side of Transit Road, at the corner of Westfield Street and Gould Avenue. The business was in operation from the mid-1930s until 1965, when it was demolished. This 1948 photograph shows the proprietor and owner, John Domino, a former mayor of the Village of Depew from 1956 to 1961.

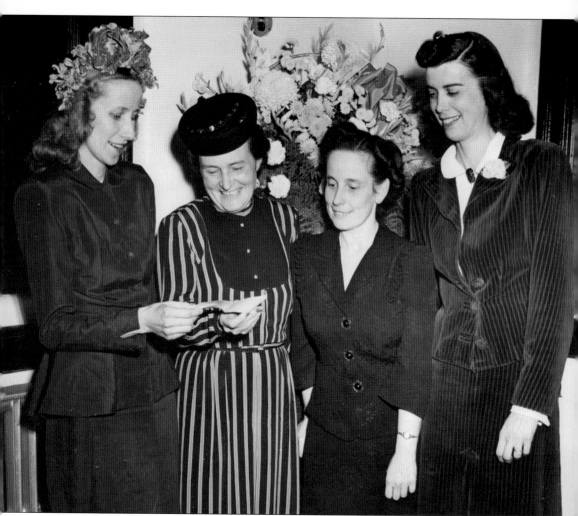

Celebrating its first quarter century of history, the Depew Branch of the Lancaster Public Library opened its doors November 1, 1947, to its new home, a small room in the Depew Village Hall. At the formal opening ceremony, Depew Women's Club president Margaret Stock, left, presents a check to Dr. Olive Lester, library board president, for additional books to be purchased for local use. The others are unidentified.

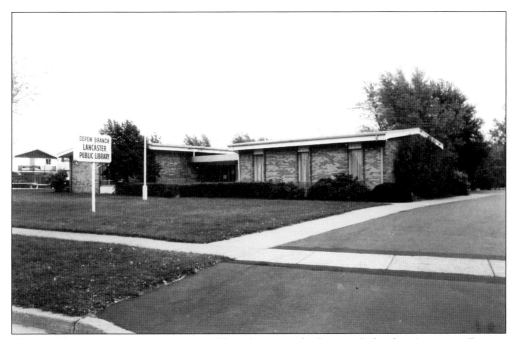

The Depew Branch of the Lancaster Public Library was built at 34 Columbia Avenue in Depew. Ground breaking took place on March 7, 1964, and the cornerstone was laid on September 26 that year. The opening and dedication occurred on Saturday, February 20, 1965. However, the library was later closed due to a lack of funding.

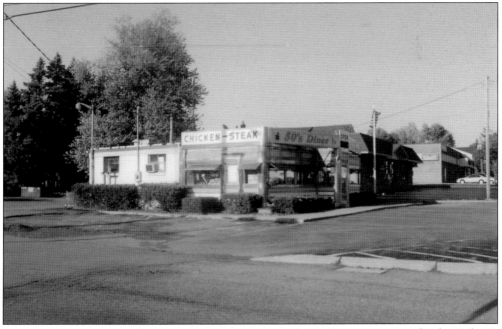

August 4, 1955, was most definitely ranked as a banner day in Depew, as it was the day Robert's Restaurant arrived in the village. The structure is a full-fledged diner, manufactured by Silk City Diners in Patterson, New Jersey, and named after the original proprietor, Robert Estes. In recent years, under new ownership, it was renamed the '50s Diner.

Typical of the Howard Builders subdivision, this view of Fairview Court shows the low-priced homes constructed in the 1950s. Components were partially constructed in a facility on Walden Avenue, then moved to the site where the homes were erected slab on grade. The lack of a basement and the method of construction led to an economically priced home for the buyers.

This concrete and brick structure was built in Veterans Park in the 1960s to replace an old wooden bandstand. The structure was originally intended to be a multiuse facility serving as a wading pool, ice rink, venue for Memorial Day and other services, and for outdoor concerts. Due to multiple structural problems, it was abandoned and demolished.

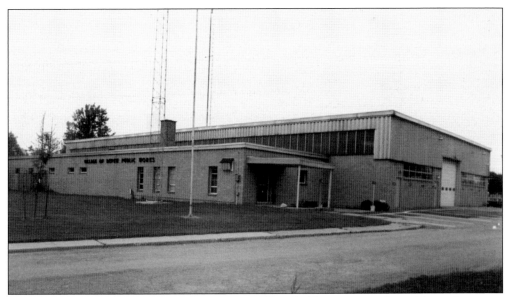

Depew's first municipal building to be constructed in a half century was the public works garage on the east side of Borden Road, just south of Broadway. The cornerstone was laid on Sunday, August 26, 1962. Public works trucks, equipment, storage, office space, and a two-way radio system were part of the installation.

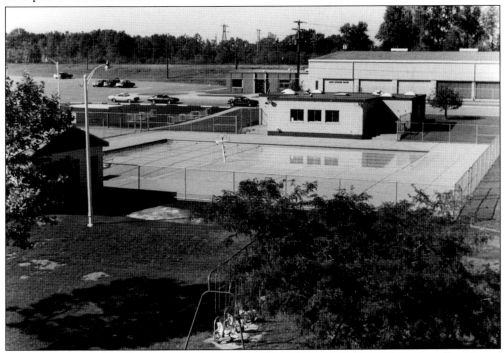

A swimming pool for Firemen's Park was proposed in July 1966. In December, the village board of trustees authorized plans and specifications for the swimming pool complex, and bids were awarded with construction to be completed prior to the 1967 summer season. On July 31, 1967, a plaque inscribed to the memory of Mayor Eugene V. Ziemba was affixed to the swimming pool complex building.

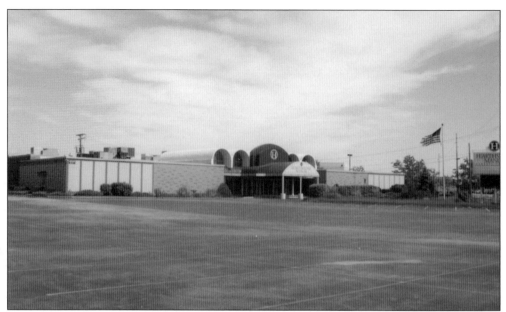

Hearthstone Manor, located on the east side of Dick Road, was opened in 1966 as a banquet facility. The facility, which can accommodate up to 2,000 guests, has been the site of many weddings, banquets, meetings, and other social events and entertainments. It was sold in 2014 and will continue as a banquet facility under new management.

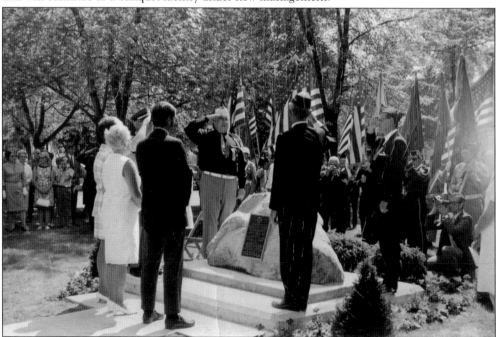

On Sunday, June 18, 1970, a memorial to Dr. Albin V. Kwak, a Depew physician for 34 years, was dedicated by a grateful community. The stone and plaque are a lasting memorial reminding future generations of his work. As veterans and service groups stand at attention, members of the Kwak family pause in front of the monument at Warsaw Street and Terrace Boulevard across from the post office.

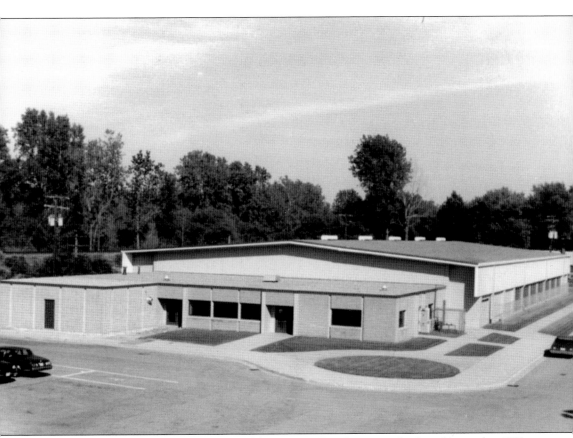

An ice-skating arena and pavilion on Gould Avenue at Erie Street was built and opened in 1971. Partial funding for the pavilion was secured by then congressman Jack Kemp under an open-air grant through the efforts of Mayor John J. Potter and the village board of trustees. The ice arena was enclosed in 1975.

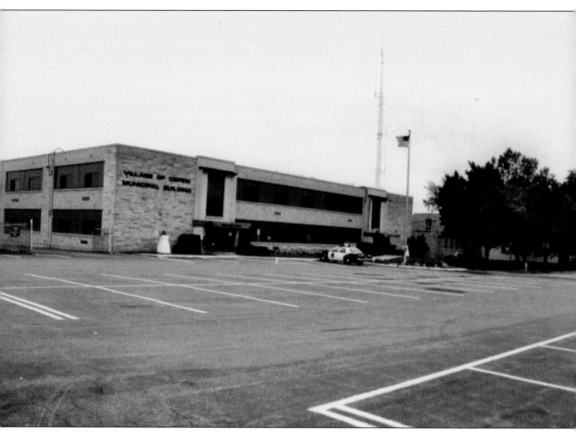

The Village of Depew purchased the former St. Augustine's Parochial School and convent on Manitou Street and Gould Avenue after the school was closed in 1975. The building was then converted into a village hall with offices on the first floor and the village justice court on the second floor. The convent was remodeled into a police station, including jail cells for temporarily holding prisoners.

Four

FIRE DEPARTMENT

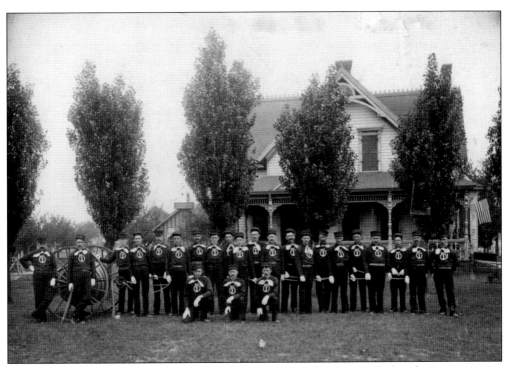

Depew Hose Company No. 1 was the first fire company to be organized after the incorporation of the village; it was chartered on December 3, 1894. The company is pictured here in full dress uniform with their hose cart around 1900 on Anthony Hartung's property on the northwest corner of Transit Road and Ellicott Road. Hartung's cigar factory and home are in the background of the photograph.

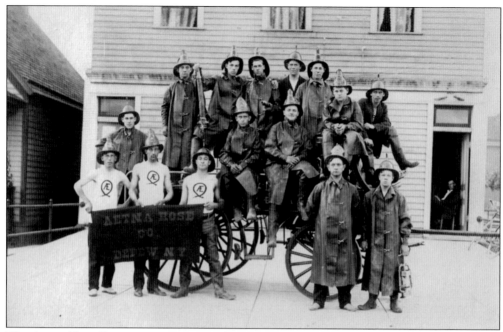

The Aetna Hose Company was organized in 1895. Members displayed their new hose cart in early 1901 at the front of the south-side firehouse. The hose wagon was built by Fred Handel of Lancaster at a cost of $380.

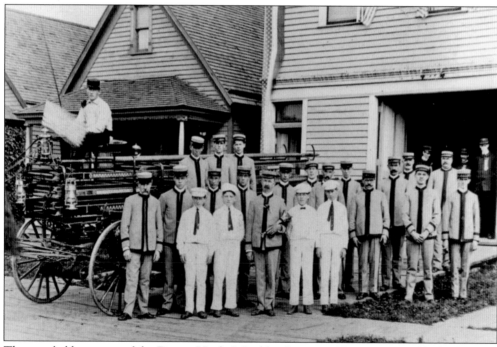

The new ladder wagon of the Depew Hook & Ladder Company No. 1 was proudly displayed by the fire company members in 1897 at the south-side firehouse at Gould Avenue and Penora Street. John Carlson (second from left, second row) served as chief of the Depew Fire Department for 17 years and worked to completely motorize the five fire companies that formed the department.

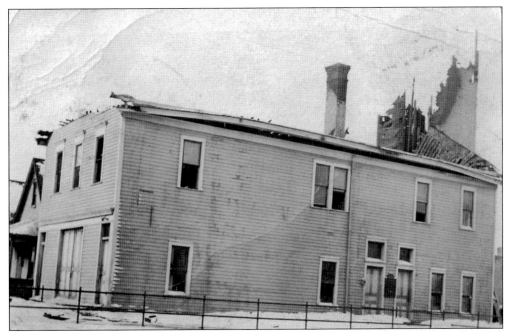

The south-side firehouse built in 1896 was destroyed by fire on January 11, 1912, after attempts to thaw frozen water pipes with a blowtorch. The building and adjoining hose tower was made of wood frame construction. At the time of the fire, the building also housed the village board council chambers as well as the police department and jail. A similar firehouse was built on Ellicott Road to house Depew Hose Company No. 1.

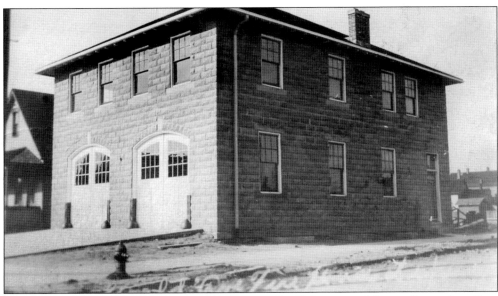

Following the destruction of the original firehouse at Gould Avenue and Penora Street, the village board accepted a bid of $5,070 for the construction of a new concrete block structure on June 17, 1912. In February 1913, the Aetna Hose Company and the Depew Hook & Ladder Company No. 1 took up occupancy in the firehouse and occupied the building until 1964.

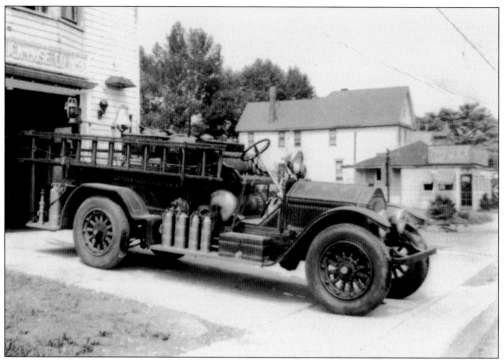

In 1898, the Cayuga Hose Fire Company was organized in the village. The company took possession of their firehouse on the northwest corner of Broadway and River Street on April 1, 1909. Their 1927 American LaFrance fire engine is displayed on the ramp of the firehouse. The building on the opposite corner was Vic's Diner.

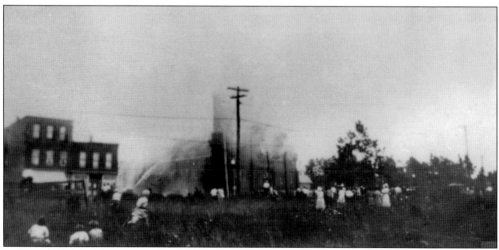

Local residents gather to watch as a general alarm fire on August 21, 1930, totally destroys St. James Catholic Church on Terrace Boulevard and Easton Street. The English-Gothic structure had just been redecorated three years prior to the fire. The steeple housing a 600-pound bell crashed down from the tower into the basement of the structure. (Courtesy of Fritz Noll.)

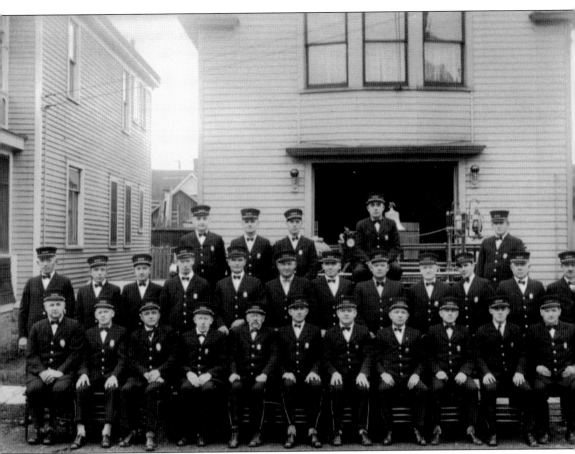

Central Hose Company No. 4 members pose in this 1930 photograph with their American LaFrance fire engine. The building in the background is the company's headquarters, erected in 1909 on the west side of Harlan Street near Burlington Avenue. The fire company, which was organized in 1902, would occupy the firehouse until October 1964, when the company moved into a new fire station.

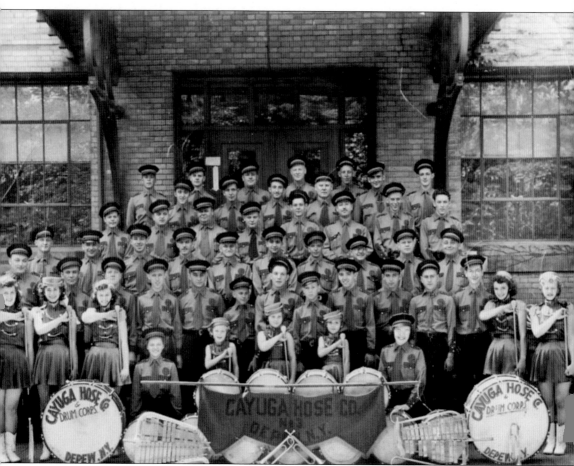

The Cayuga Hose Company Drum Corps is pictured here on May 30, 1949, after taking part in the annual Memorial Day program. The drum corps was organized in the summer of 1924, and they were called the "Green Hornets" on the parade circuit. They were one of the best in the area, and in 1957, the corps won first place honors at the Convention of the Southwestern Association of Volunteer Firemen.

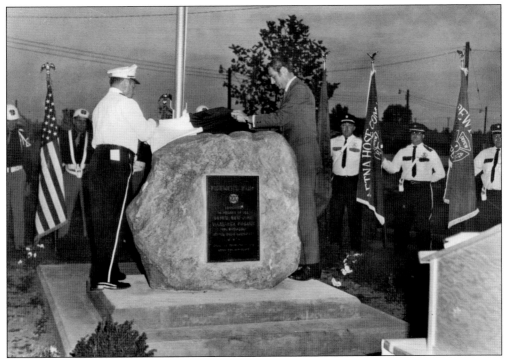

In 1950, responding to a request of the Depew Fire Department, the village acquired 12 acres of land at Terrace Boulevard and Erie Street as a site to hold field days and picnics. In 1961, the Twin Village Post 463 VFW urged that the park be named Firemen's Park to honor all firemen. On September 12, 1970, a stone monument officially marking the name Firemen's Park was unveiled by Mayor Joseph Natale and fire chief Robert Fiegl.

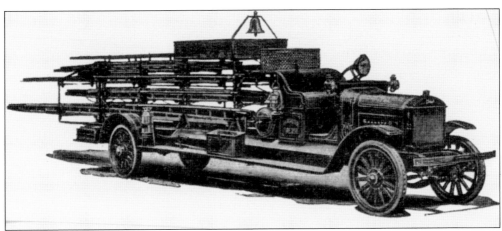

A 1920s city service ladder truck on a Stewart Chassis built by Obenchain-Boyer and supplied by Buffalo Fire Extinguisher Company was delivered on September 10, 1920, for use by the Hook & Ladder Company No. 1 of the Depew Fire Department. The ladder truck and two pumping engines were the first motorized vehicles to be put in service by the Depew Fire Department.

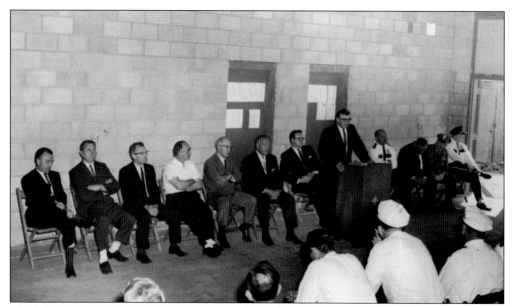

The laying of the cornerstone for the new Southside Fire Station at Meridian and Minden Streets was held on June 6, 1964. Village trustee Edward Wargala, at the podium, served as chairman of the building committee. Others in the photograph are, from left to right, Eugene Ziemba (trustee), John Potter (trustee), Bernard Elmore (trustee), Marco Guerra (school superintendent), Julius Volker (assemblyman), John Domino (mayor), Thaddeus J. Piusienski (village justice), Walter Dyll (fire chief), William Gonglewski (DPW superintendent), Louis Wenzka (police chief), and Joseph Schultz (village attorney).

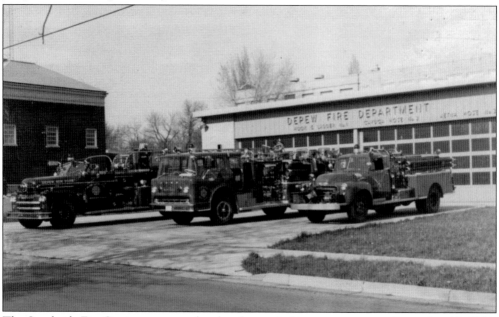

The Southside Fire Station was completed and occupied in a ceremony on September 12, 1964, on Meridian Street between Terrace Boulevard and Minden Street. It houses the Depew Hook & Ladder Company No. 1, Cayuga Hose Company, and the Aetna Hose Company. This photograph was taken on May 14, 1967.

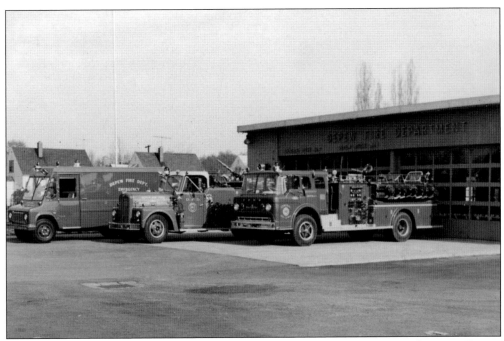

The Northside Fire Station, located on Brewster Street off Olmstead Avenue between Transit Road and Lincoln Street, was built in 1964 and occupied on October 17, 1964, by Depew Hose Company No. 1 and Central Hose Company No. 4. This photograph was taken on May 14, 1967, when the newly acquired emergency truck was dedicated.

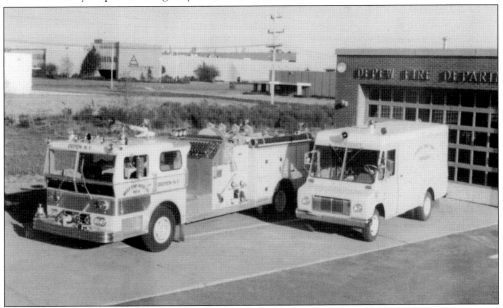

The West End Fire Station, located at 2325 George Urban Boulevard, was first occupied in 1969. In this 1977 photograph, the new engine put in service by the West End Hose Company and the newly repainted rescue truck were displayed on the ramp of the West End Fire Station. The Arcata Graphics Printing Plant is in the background of the photograph in the TC Industrial Park on George Urban Boulevard.

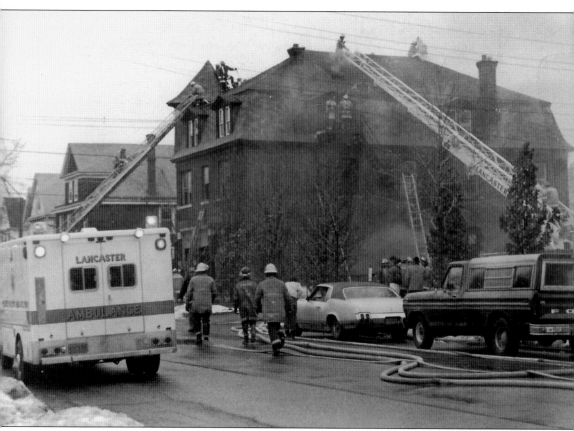

A possible tragedy was averted early on New Year's morning in 1982 when Depew firefighters responded to an alarm of fire at an apartment complex at the northeast corner of Terrace and Penora Streets. The firefighters and police officers helped 14 tenants escape by ladders and a fire escape. An individual was arrested for setting the fire, charged, and convicted of arson.

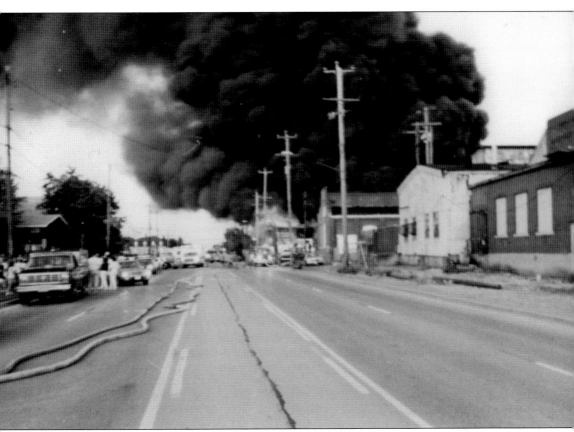

On Sunday evening, August 30, 1987, the fire department faced the largest fire in the history of the village as the commercial building complex at Transit Road and the south side of Walden Avenue went up in flames, destroying C Kitchen Associates and the Interstate Tire Company. The building formerly housed the Muffets Division of the Quaker Oats Company.

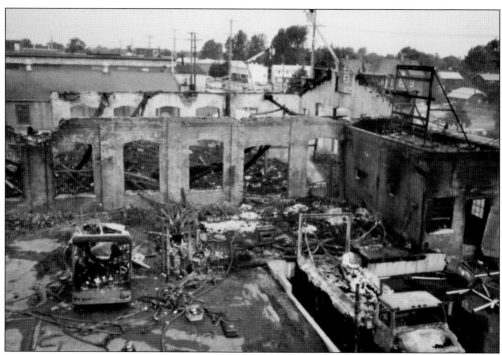

The remains of the C Kitchen Associates fire show what was left of one of the village's oldest industrial sites. The devastating fire roared throughout the various buildings and destroyed the complex, which dated back to the late 1890s. The cause of the fire was investigated by the ATF and thought to be electrical in nature.

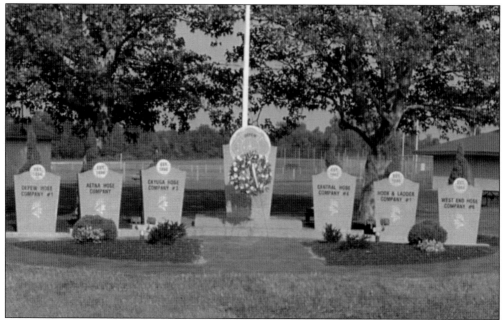

A Firemen's Memorial to honor the past and present members of the Depew Fire Department was dedicated on September 10, 2005. A walk of honor made of inscribed bricks recognizes all of the past chiefs as well as all former members who chose to have their names put on the bricks.

Five

POLICE DEPARTMENT

The 18th Amendment to the Constitution prohibiting the manufacture and sale of intoxicating beverages became law on January 7, 1920. Attentions of federal agents quickly focused on Depew with its many saloons and soft drinkeries. This property at Gould Avenue and Transit Road was raided in November of that year. The owner claimed he had just bought the building and was unaware of the fully operating whiskey still inside.

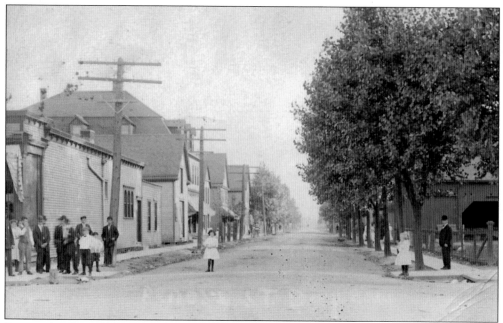

Despite their best efforts, federal agents were unable to stop the manufacture of alcoholic beverages in Depew. This view of Penora Street shows some of the buildings engaged in the trade. Four places were raided in November 1929, and the value of equipment and materials was reported to be tremendous. (Courtesy of Jack Roskoz.)

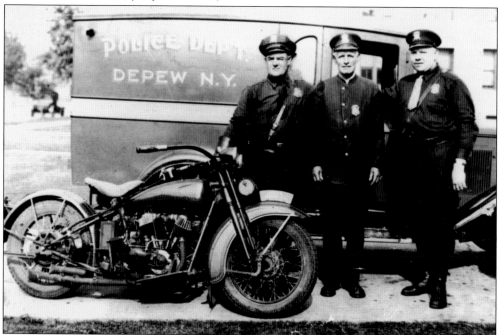

One of the first orders of business for the village board after the incorporation of the village of Depew in 1894, was the appointment of three constables to enforce the laws. In 1928, patrolman John J. Gainey, Chief Philip Mehl, and patrolman Frank J. Winkler posed with this newly acquired motorcycle and paddy wagon.

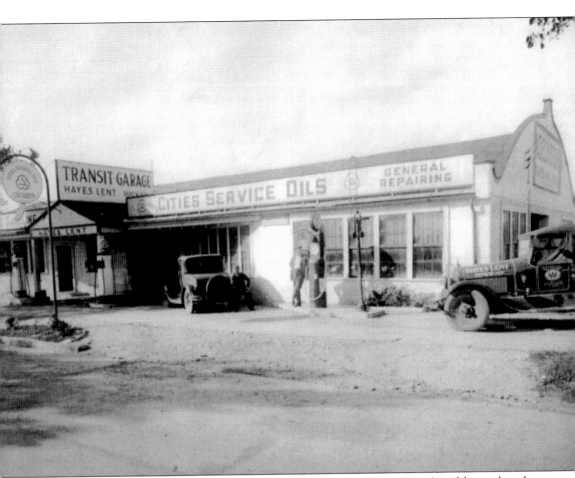

The Transit Garage was owned by Hayes Lent (standing at the gas pump) and located at the southwest corner of Transit Road and Terrace Boulevard. On October 30, 1933, at the garage, Hayes Lent shot and killed Leo Bajerski, a Lancaster police officer, and then turned the gun on himself.

One of the most colorful characters from Depew's Prohibition era was John "Big Korney" Kwiatkowski, who operated a soft drink place at 49 Main Street. He was one of Buffalo's premier gangsters, with a long record of robbery, bootlegging, and murder. Big Korney was finally sent to Auburn prison in 1930. He was released in 1944 and operated a poultry farm in central New York until he died on December 16, 1964.

Members of the Depew Police Department stand on the steps of the village hall and police station on Terrace Boulevard in 1934. From left to right are (first row) Chief Gustave Kanehl, police justice Alexander Utecht, and Lt. Frank Winkler; (second row) patrolman Arthur Marggrander, Louis Konwiczka, Charles Konwiczka, and Sgt. John Gainey.

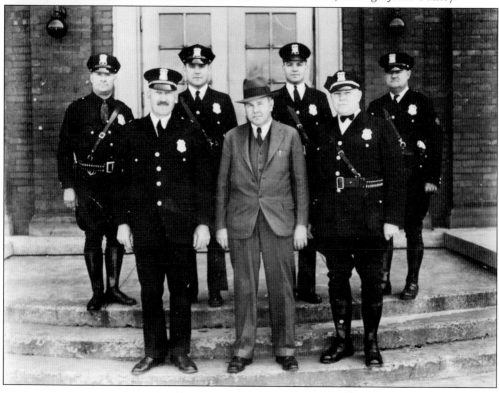

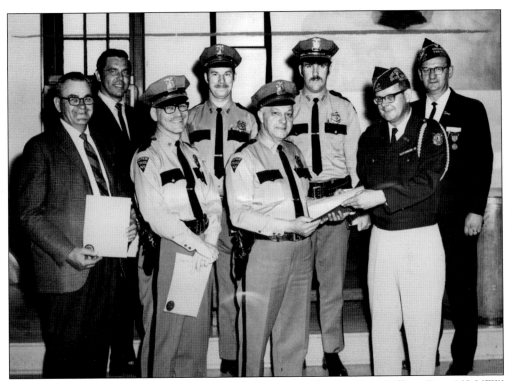

Members of the Depew Police Department were honored by the Twin Village Post 463 VFW for their services in safeguarding the lives and property of Depew residents. Pictured here are, from left to right, (first row) Edward Wawrzyniak (director of civil defense auxiliary police, Post Award), police chief Louis R. Wenzka (National VFW Award), Lt. Raymond Cybulski (National VFW Award), and Erie County commander Ray Palkowski; (second row) Lt. Richard Rybak (Post Award), Ronald Vohwinkel, John Plunkett (Erie County Council, VFW Award for life saving), and post commander of Twin Village Post 463 VFW, Richard Zmozynski.

A monument dedicated to the men of the Depew Police Department recognizing their services for a better community, gratefully presented by Twin Village Post 463 VFW, was dedicated on November 11, 1972. Police chief Louis Wenzka (left) and Lt. Roy Mapes (right) prepare to place the wreath as police officers and other dignitaries look on.

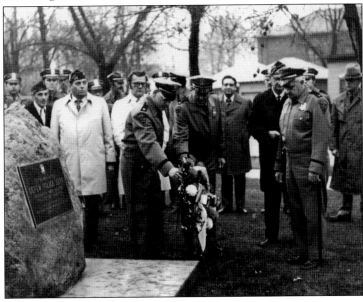

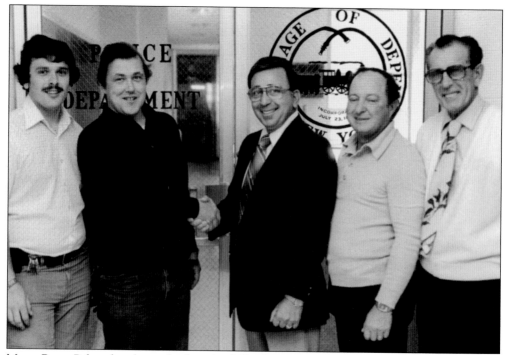

Mayor Roger Paluszak welcomed police chief John Maccarone and the Depew Police Department to its new headquarters in the former St. Augustine's convent in 1979. The new quarters housed a communications center, offices, and jail cells. From left to right are Donald Snios, Paluszak, Maccarone, highway superintendent Vincent LiPuma, and deputy mayor Henry Wienckowski.

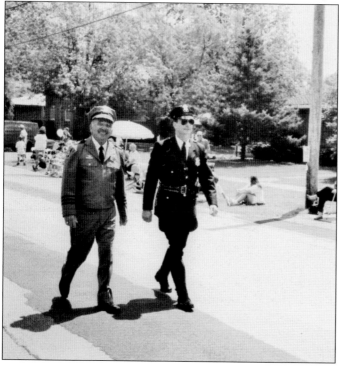

The Village of Depew Centennial Parade was held on Saturday, July 23, 1994, exactly 100 years from the date of the incorporation of the village. Marching in the parade is longtime police chief John T. Maccarone (left) with police officer Steven Lehman wearing a vintage motorcycle officer's uniform from the 1930s.

Six

CHURCHES

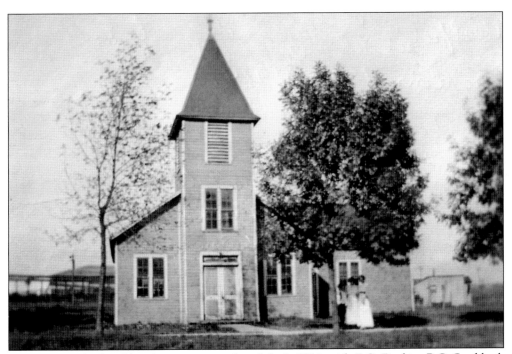

The First Methodist Church was organized on July 6, 1894, with E.C. Durbin, B.C. Stoddard, and A.W. Southall as trustees. The Reverend J.K. Orme became the first pastor in 1895. Plans for a new church at Westfield and Meridian Streets were drawn up the following year. The church was dedicated on February 20, 1898.

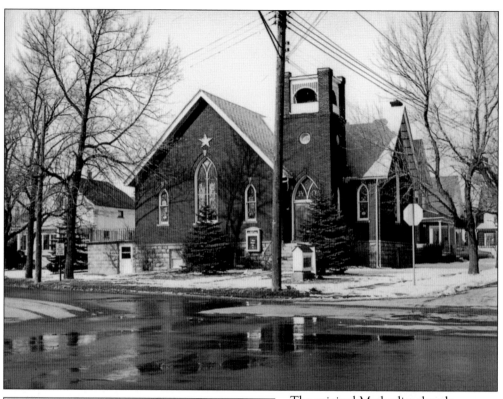

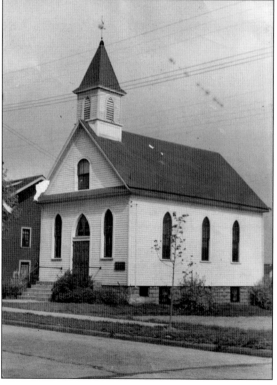

The original Methodist church building was demolished in 1913, and a new brick structure was constructed to house the growing congregation. The new house of worship was built at the corner of Westfield and Meridian Streets and dedicated on May 24, 1914. Today, it is home to the Restoration Church Twin Village.

The St. John's Lutheran Church was originally built on Kokomo Street between Gould Avenue and Terrace Boulevard and dedicated on April 14, 1895. In 1913, the congregation decided to move the church to Litchfield Street. In 1940, they voted to build a new sanctuary and to convert the old church into Sunday school facilities. (Courtesy of Rev. Galen M. Purpura Jr.)

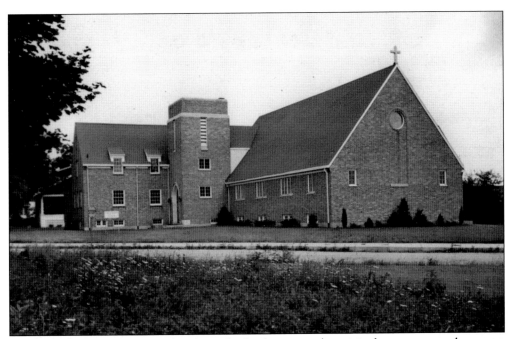

The new St. John's Lutheran Church was built adjacent to the original sanctuary on the corner of Litchfield Street and Wilton Street (now JFK Court) in 1960. In 1965, in order to provide more adequate facilities for the growing congregation, an addition was built on the rear of the church.

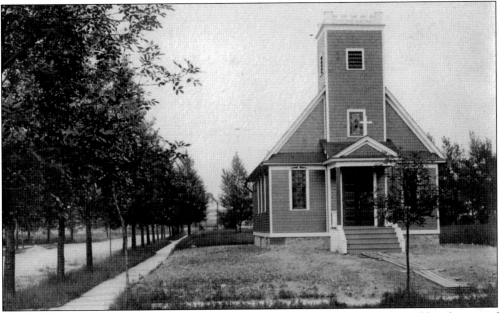

St. Andrew's Episcopal Mission was organized in 1896, and services were held in homes of members until November 14, 1897, when they moved to a bank building. The Depew Improvement Company donated three lots for the congregation on the corner of Rumford and Eliot Streets. A cornerstone was laid on November 11, 1906, and the mission was opened on July 5, 1907. After several years, as the membership dropped, the mission was demolished.

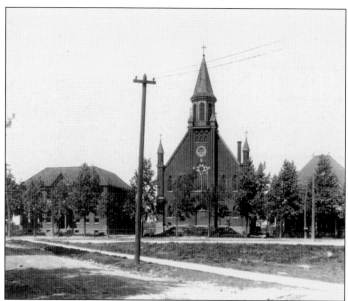

The first Roman Catholic parish in Depew began in 1896 when Rev. Peter Basinski celebrated mass for six families in a private residence on Houston Street. Built on land donated by the Depew Improvement Company, SS. Peter and Paul Church was dedicated on July 10, 1898, before a crowd of 4,000 people, brought to the site by train and trolley. It became the center of a thriving community of Polish immigrants.

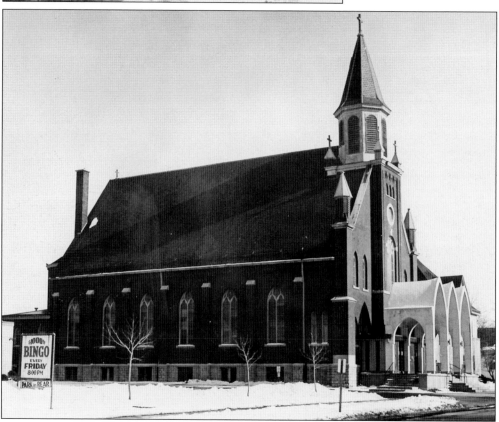

The early years of the 20th century saw rapid expansion of the parish. A school opened in 1905, and the rectory was completed in 1907. In April 1910, Rev. Stanislaus Fimowicz bought 20 acres of land on Olmstead Avenue and began selling lots at low prices to help build up the neighborhood. The convent was completed in 1913.

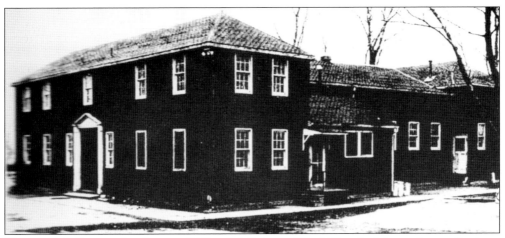

The parish hall opened in January 1940 at SS. Peter and Paul Church. It housed an auditorium, stage, kitchen, and bar. School plays were performed here as well. As a social hall, it witnessed many a dance, card party, and wedding reception. The 1960s saw the demolition of the school, convent, and hall, replaced by a new building that served all three functions. The church was joined to the rectory with a new facade.

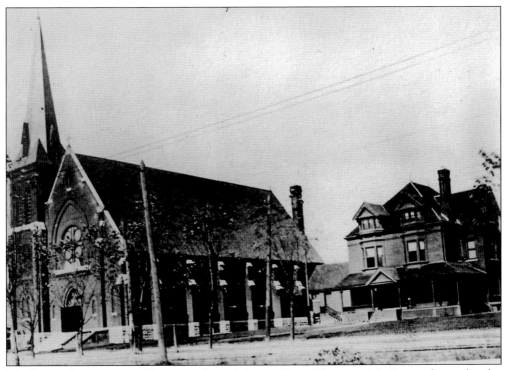

The Depew Improvement Company, through its president Chauncey M. Depew, donated a plot of land on Terrace Boulevard between Easton Street and Wilton Street as a site for the St. James Catholic Church and parish house. Ground was broken on August 8, 1898, and the cornerstone was laid on September 18, 1898. The new church was dedicated on March 15, 1899. The original church was destroyed by fire on August 21, 1930.

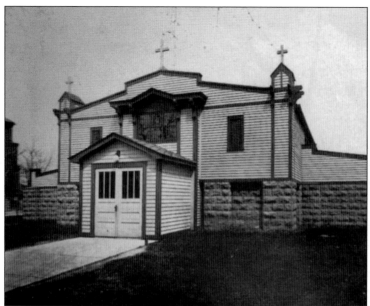

Rev. Anthony Majewski was appointed to organize St. Augustine's Church on May 26, 1909. The original church was built on Penora Street between Gould Avenue and Terrace Boulevard in 1917. Designed as a basement school with an upper sanctuary, it was never completed due to lack of funding. Services were held in the basement until February 1951, when the church was destroyed by fire.

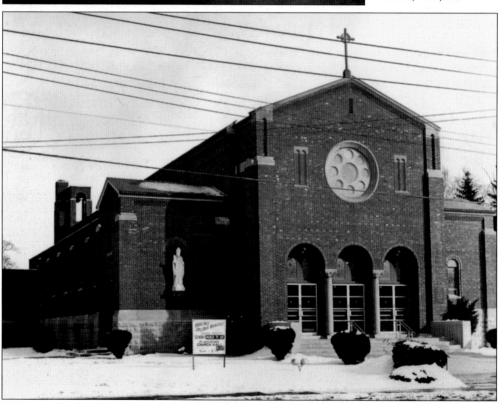

Following the fire that destroyed the original St. Augustine's Church, the newly appointed pastor, Rev. Ignatius Wojciechowski, organized a building committee, and the work of constructing a new church commenced in August 1952. The cornerstone was laid on July 26, 1953, and the mass of dedication was celebrated on December 20, 1953. The church was closed in June 2009 when the parish was merged with St. James Catholic Church to become the Blessed Mother Teresa Parish.

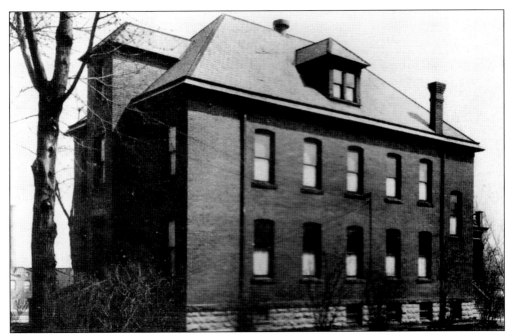

In 1909, St. Augustine's Church began the construction of a convent to house the nuns of the Felician Order who taught in the school. Designed by Wladyslaw H. Zawadzki, it was built of red brick and stood at the corner of Manitou Street and Gould Avenue. It served as a residence until a new school and convent were opened in 1966. It has since been demolished.

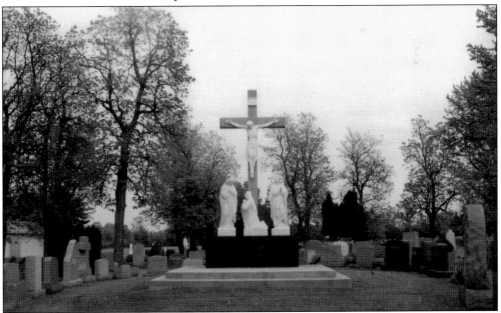

In 1919, St. Augustine's Church acquired 30 acres of land on Cemetery Road in Lancaster, thus becoming the only Depew church to have its own cemetery. A section was set aside in 1946 for the burial of World War II casualties and an altar topped by a cross was built, but the plans for that plot were abandoned as families preferred to bury their loved ones in their family plots. Seen above are individual family plots.

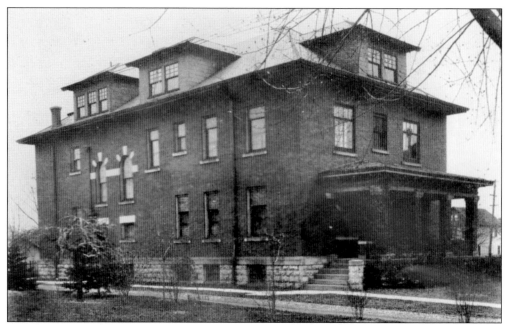

The rectory for St. Augustine's Church was under construction in 1921 and completed the following year. This building replaced the original rectory, a house purchased from Dr. H.M. Jack in 1909, which stood at the southwest corner of Gould Avenue and Penora Street across the street from the south-side firehouse.

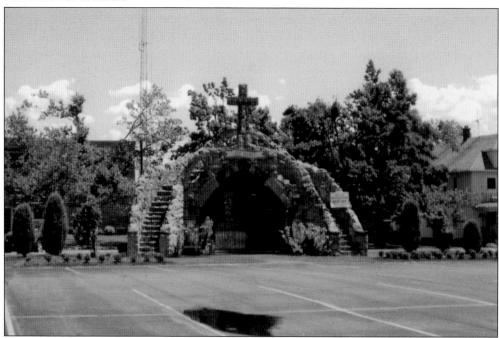

Parishioners of St. Augustine's Church gathered stones to build a stone grotto on the church grounds, but a lack of funding slowed the process. In the mid-1930s, the Depew Hook & Ladder Company No. 1 raised $300 to help fund the project. John Stepien, a parishioner, built the grotto without any plans. It was dedicated on August 15, 1937, in honor of Our Lady of Lourdes.

The First Love Christian Fellowship occupies this building at 3144 George Urban Boulevard. Originally built in 1940 by the Assembly of God, it has served as home to a number of congregations before it was acquired by the present owners in 2001. Dedicated on September 9, 2001, it retains the pews installed by the original owners.

The first meeting of the Bible Fellowship Church was held November 14, 1953, in a garage on Hanwell Place. By 1956, plans were made to erect a church on Rehm Road, and construction began in September 1957. The name of the church was changed to Hillview Baptist Church, and the church was dedicated during the week of October 1, 1961. In 1975, the congregation erected a new church adjoining the original structure.

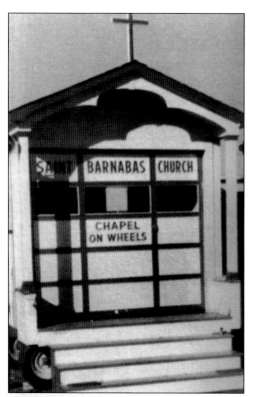

St. Barnabas Church was officially established on June 13, 1960. Masses were celebrated at the Aero Drive-In Theatre in "Our Chapel on Wheels." Richard and Walter Horst built the portable altar to protect the celebrants from the elements. In the winter, masses were moved to an airplane hangar at the Buffalo Aeronautics Corporation. It was used until ground was broken for a permanent building the following year.

The first mass in the permanent St. Barnabas Church building was said on November 12, 1961. The hall, located at 2049 George Urban Boulevard, could hold 600 people. Population growth was so rapid that by 1967, a new 1,100-seat church was opened. In 2011, the congregation merged with Our Lady of the Blessed Sacrament to become St. Martha Parish. The building was reopened as the Western New York Cantalician campus.

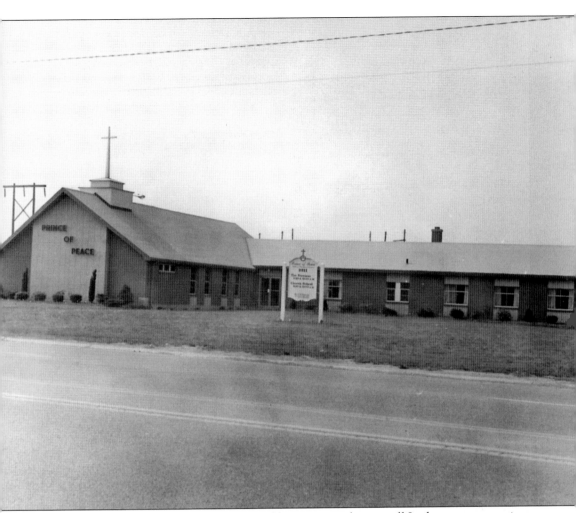

Prince of Peace Lutheran Church was formed by a merger of two small Lutheran congregations located in Buffalo, New York. The first worship service was held on Thanksgiving Day 1964. On December 4, 1966, a new building was dedicated by Rev. E. Philip Sebastian. It stands at 2311 George Urban Boulevard.

Our Lady of the Blessed Sacrament Parish began in 1965 with the acquisition of an abandoned farmhouse in a field off George Urban Boulevard. Sunday masses were held in the cafeteria of St. Mary's High School until the church opened the following year. In 1979, parishioners made the final payment on the mortgage.

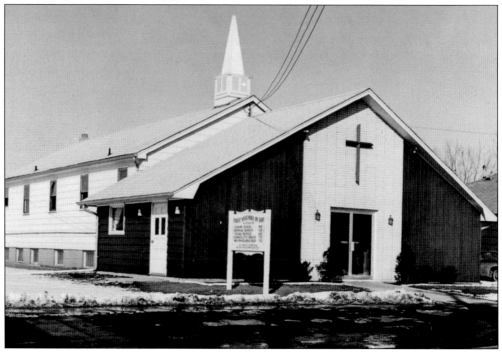

The First Assembly of God Church opened in 1954 with temporary quarters on Transit Road. A new church was built in 1956 at 410 French Road with an addition constructed in 1967. In 1999, the church was sold to the New Cavalry Baptist Church, which moved from its former location on George Urban Boulevard.

Seven

SCHOOLS

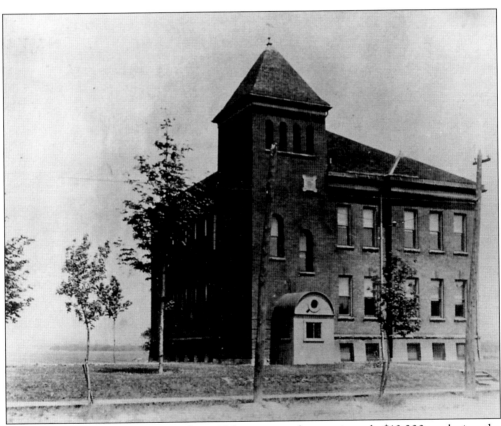

The Broadway School was opened in 1895 at a cost of approximately $10,000, replacing the original school building which stood behind the new school. It was located on the north side of the Cayuga Creek Plank Road (Broadway) between Lackawanna and North Bryant Streets. The structure would remain in use until the late 1950s, when it was turned into a community building. The building was eventually demolished.

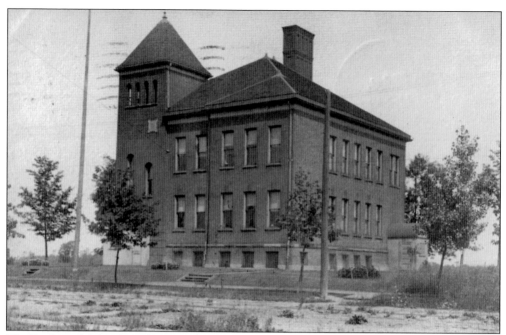

The Boulevard School was built on the north side of George Urban Boulevard to accommodate the children on the north side of the village. A twin of the Broadway School, it was used until 1927, when the state school inspectors declared the building unfit for use and ordered it closed. It later served as a restaurant before it was demolished.

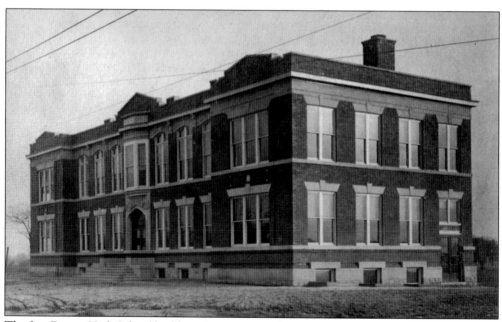

The first Depew High School building was constructed on Terrace Boulevard and Marengo Street across from the village park. It opened on January 1, 1908, and served the needs of the village, as it was located in the center of the village proper. The two-story structure had an auditorium and measured 154 feet by 82 feet. It was destroyed by fire on the morning of June 21, 1913.

After the original Depew High School was destroyed by fire, the building was demolished and replaced by a new fireproof structure. Constructed of brick and stone, it stood three stories high and opened on April 4, 1914, as a new grammar and high school. It was designed by architect E.E. Joralemon and was built by Alexander Utecht. It would continue to serve as a high school until 1954, when a new building was constructed.

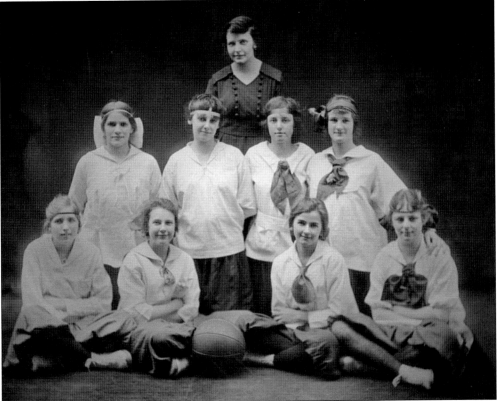

Depew High School was the sponsor of a girls' basketball team in 1914, which was one of the first organized female athletic teams in the school's history. A Miss Taylor, the coach, is pictured here with, in no particular order, Hattie Brandenburger, Irene Bund, Veronica Williams, Marian Martin, Camille Weiss, Ruth Bardol, and Evelyn Phillips.

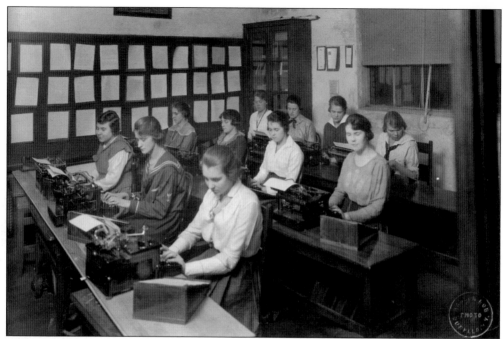

Depew High School organized an evening school in 1918 for persons over 16 years of age who had entered a trade. More than 200 people enrolled, with 40 in the commercial department. In touch typewriting class, women would become familiar with various makes and models of typewriters used in business offices of the day.

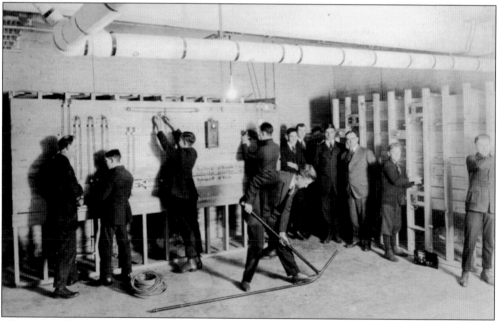

Those enrolled in theoretical electricity were men who were actually engaged in the electrical industry. In these classes, the men learned practical applications, as well as the theory of electrical engineering. They learned how to wire motors, switches, and fuses, and they actually produced four motors, which were used in the woodworking department.

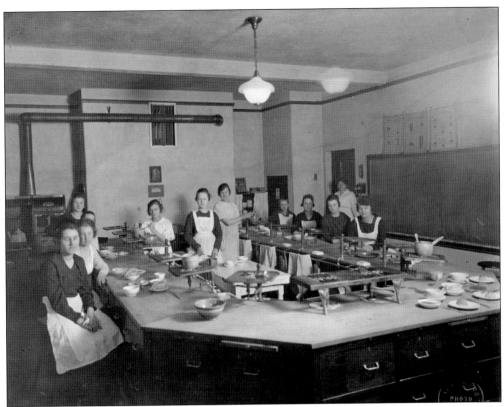

The domestic science department attracted 14 students in 1919, which was the first year the course was offered. After a long day at the office, store, or home, these women considered the class to be both recreation and study. They learned to cook everything from bread and candies to soups and vegetables.

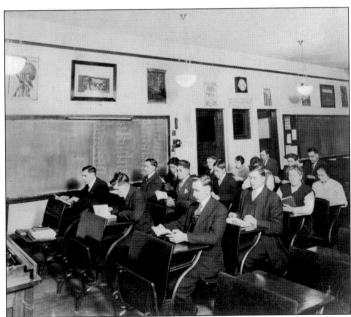

Americanization Class was offered to foreign-born residents in the community. The industries in Depew attracted a great number of illiterates and non-English speaking people looking for work. Both men and women studied English to make themselves eligible to apply for American citizenship.

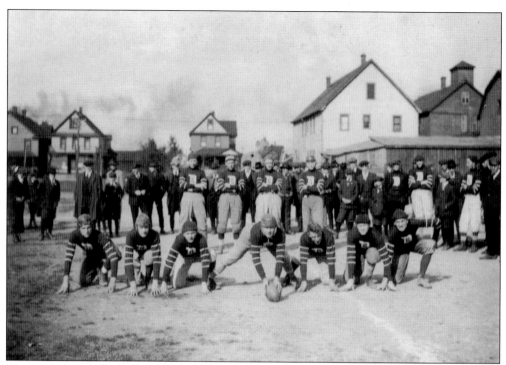

The 1919 Depew High School football team lines up prior to a scrimmage game against Pop Petty's All-Stars at Renova Park on Laverack Street. The scrimmage preceded the first-ever football game against Lancaster High School in what was to become a long-standing rivalry that lasted for more than 90 years.

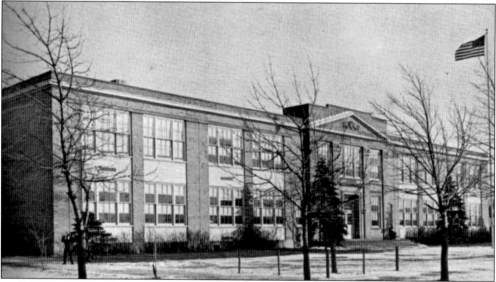

In 1925, the citizens living in the northeastern section of the village petitioned to have a new junior high school built to accommodate overcrowding of the SS. Peter and Paul Parochial School and the inadequacy of the Boulevard School. The board of education responded by having architect Frank A. Sprangenberg design a new building. Local contractor Alexander Utecht built it in 1926.

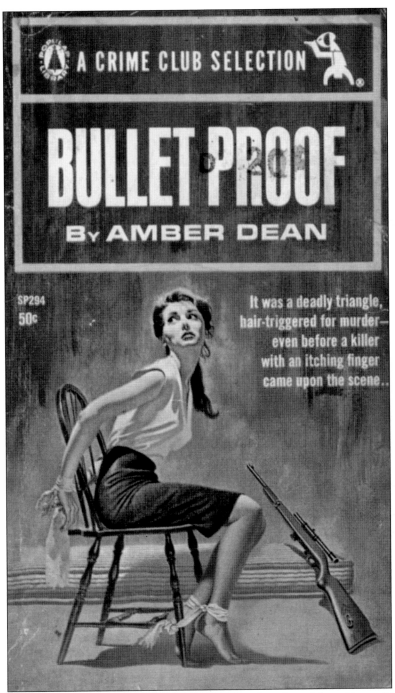

A CRIME CLUB SELECTION

BULLET PROOF

By AMBER DEAN

SP294
50¢

It was a deadly triangle,
hair-triggered for murder—
even before a killer
with an itching finger
came upon the scene..

Mystery writer Amber Dean was born in Depew in 1902 and graduated from Depew High School with the class of 1922. She moved to Rochester in the 1930s with her husband, Norman Getzin, where she spent the rest of her life. In addition to writing 17 mystery novels, she lectured on writing to clubs and organizations and judged flower shows for the Federated Garden Clubs of New York State. During the Vietnam War, she worked tirelessly on behalf of Operation Morale, a volunteer organization that sent care packages to men in the service. She died on June 3, 1985.

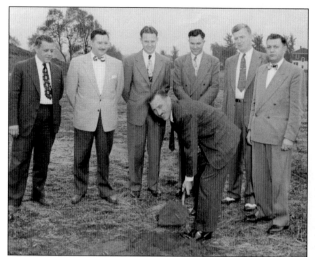

In early 1952, ground was broken for the construction of the modern Depew High School building located on Transit Road. School board president Joseph Trojanowski turned the spade as, from left to right, board members Sidney Lewis, John Sauer, Adolph Kotz, John Paluszak, superintendent of schools William Phelan, and Joseph Natalzia looked on.

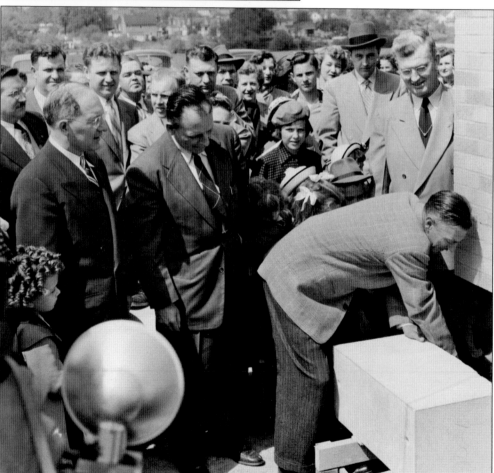

The cornerstone for the first wing of the junior-senior high school was laid on May 18, 1952, with more than 300 individuals in attendance. Pres. Joseph Trojanowski did the honors as state assemblyman Julius Volker, state senator John Cooke, and Supt. William Phelan looked on.

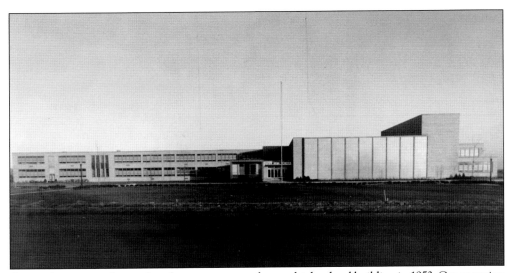

As population growth rose sharply, voters approved a new high school building in 1953. Construction began in June, and in 1954, classes started in the wing at left in the photograph above. The remainder of the building was in use by January 1955 and finally completed for use in April 1955. The first graduation was held in June of that year.

Depew Middle School, a part of the Depew Union Free School District, is located on the school campus at 5201 South Transit Road. The school opened in 1967. Designed by Donald W. Love, it serves more than 450 students in grades six through eight.

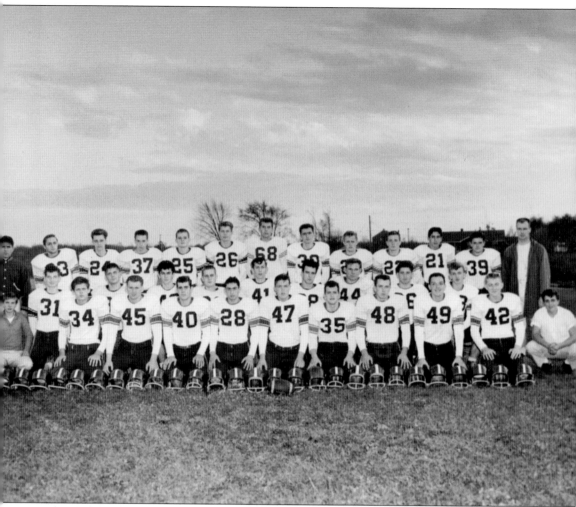

The Depew Wildcats, under their legendary coach Frank Constantino and assistant coach Raymond Morningstar, completed one of the most exciting and successful seasons ever experienced by a Depew football team. In 1959, the Depew High School Wildcats football team recorded its first undefeated and untied season in the 40-year history of the program, also winning the Division II Championship. The members of this team are from left to right as follows: (first row) P. Zybczynski. R. Pache, J. Krickovich (cocaptain), F. Ardino, R. Takacs, R. Gorski, J. Kirchofer, R. Thrun, J. Taylor, and C. Ardillo; (second row, one name missing) G. Krickovich (manager), J. Piotrowski, E. Kostecki, T. Skrabski, D. Puszert, J. Carter, L. Oleksy, T. Weichman, and G. Whitcak; (third row) Coach Constantino, J. DiPizio, T. Lorka, J. Wopperer, T. Tomala, R. Palicki, J. Babich, L. Cacciotti, M. Okal, R. Quiram, T. Cefali, F. Zielinski, and R. Morningstar.

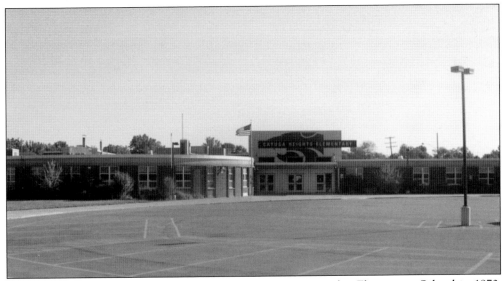

The Depew Union Free School District built the Cayuga Heights Elementary School in 1970. Located at 1780 Como Park Boulevard, it is the only public elementary school in the district. It serves more than 860 students in kindergarten through the fifth grade.

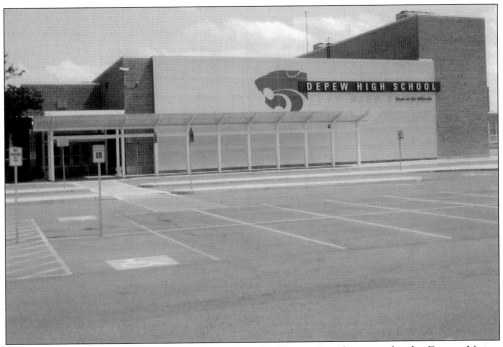

A capital improvement project implemented to the Transit Road campus by the Depew Union Free School District included the alteration of the high school facade. It included the wildcat logo, which represents the administration, as well as all of the athletic teams in the district. Once a Wildcat, always a Wildcat.

Donald "Majik" Majkowski was a 1982 graduate of Depew High School. There, he was a standout in multiple sports, earning 13 letters—four each in football, basketball, and baseball and one in track. He attended Fork Union Military Academy as a freshman, where he led the football team to an 8-0-1 record and was voted most valuable player. He transferred to the University of Virginia in 1983 and graduated as the school's all-time leader in passing yardage and total offense. A 10th round draft choice of the Green Bay Packers in 1987, he was the first ever Depew Wildcat to play in the NFL. Majkowski played for 10 years, including two years each with the Indianapolis Colts and the Detroit Lions. He was inducted into the Green Bay Packers Hall of Fame in 2005 and the Greater Buffalo Sports Hall of Fame, where he joined his former Depew football coach, the legendary Frank Constantino.

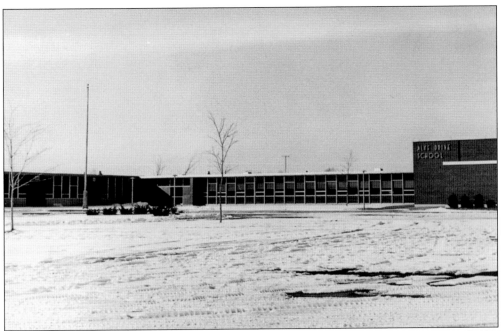

Alys Drive Elementary School, which is located at the north end of Alys Drive East and Alys Drive West, is a part of the Lancaster Central School District, which lies north of French Road in the village of Depew. The name was changed to the John Sciole Elementary School to honor a former principal.

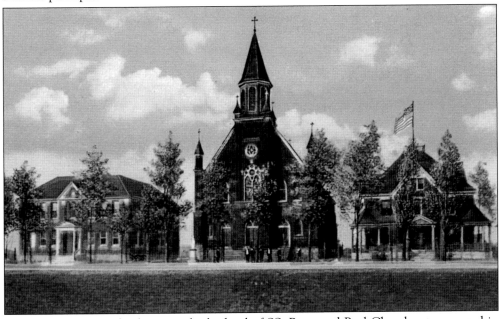

In September 1904, the first parochial school of SS. Peter and Paul Church was operated in a private home on Harlan Street. By November 1905, a brick school building was completed. Four Felician Sisters arrived in September 1907 to teach the 191 students in grades one through three. Enrollment grew to include kindergarten through eighth grade. It was replaced in 1964 by a modern building.

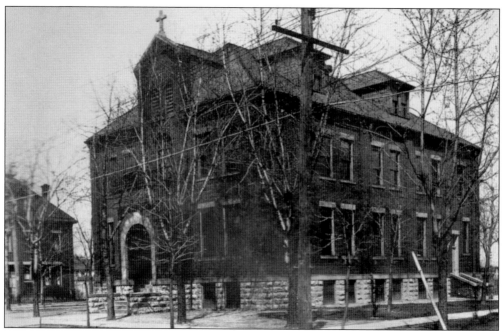

St. Augustine's Parochial School on Penora Street at Gould Avenue was originally built in 1909 as a church on the lower level and a school on the second floor. In 1912, after a new church was built, this entire structure served as a school until a new facility was constructed on Manitou Street at the end of Gould Avenue in 1965.

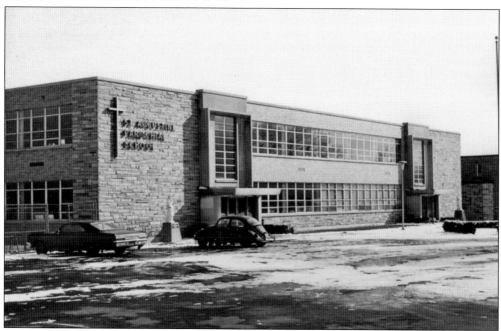

In the early 1960s, the parishioners of St. Augustine's Church decided to construct a new school building and convent. The Depew Paving Company, owned by Joseph Cerullo, was awarded the contract to construct the new facility in 1965. A ground breaking was held on June 3, 1965, and the school was opened in September 1966.

St. James Parochial School, an eight-classroom school with a combination cafeteria-auditorium, was opened in the fall of 1955. In the late 1950s and 1960s, as enrollment increased, a wing was added to the school, which included a new cafeteria. The school is located on the north side of Terrace Boulevard, adjacent to the church rectory.

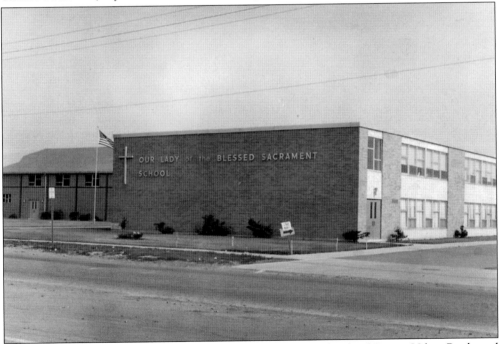

In 1966, Our Lady of the Blessed Sacrament School on the north side of George Urban Boulevard at French Road was opened as a part of the newly established Our Lady of Blessed Sacrament parish to service the needs of the community in the developed west end of the village.

Lucille Clifton was born Thelma Lucille Sayles in Depew on June 27, 1936. She was a poet, writer, and educator. She graduated from Fosdick-Masten High School in 1953, went on to study on a scholarship at Howard University from 1953 to 1955, and later studied at the State University of New York at Fredonia. From 1975 to 1985, she was the poet laureate of Maryland. Frequent topics of her poetry include the celebration of her African American heritage, women's experiences, and the female body. She was also nominated twice for a Pulitzer Prize for poetry and the first author to have two books of poetry chosen as finalists for the prize in the same year. In 2007, she became the first African American woman to be awarded one of the literary world's highest honors, The Ruth Lilly Prize for Lifetime Achievement by the Poetry Foundation. Lucille Clifton died February 13, 2010.

Eight

CLUBS AND CELEBRATIONS

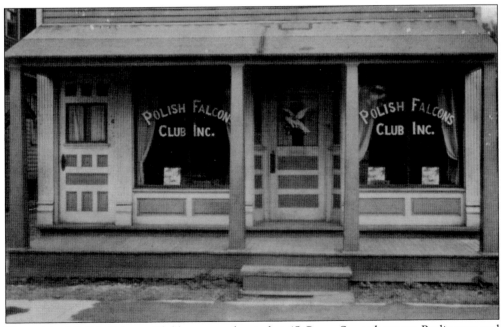

The original Polish Falcons Clubhouse was located at 45 Crane Street between Burlington and Ellicott Roads. The Polish Falcon Society of Depew was organized in 1903, and they held their meetings at various locations in the village until 1919, when the Falcons purchased their own clubhouse at the Crane Street location.

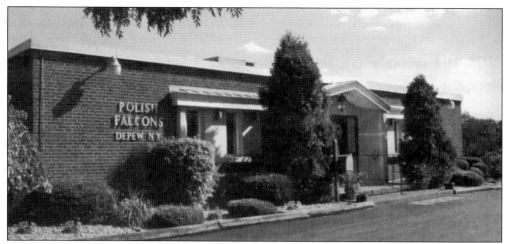

With the growth of the village in the 1960s, the Falcons saw an increase in membership and a growing need for a larger and more modern facility. In late 1970, ground was broken for the new clubhouse at 445 Columbia Avenue at Warner Road. The new facility was formally opened on September 11, 1971.

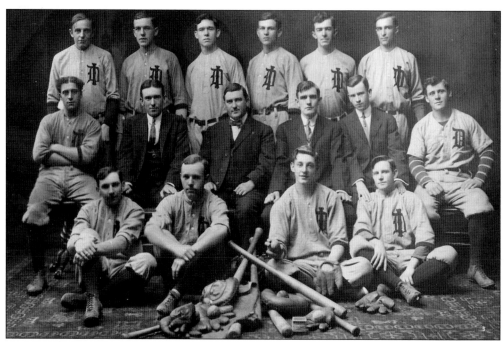

In 1910, the Depew Industrial baseball team was one of the top baseball teams in the area. Sponsored by local industry, Wally Schang (seated at extreme right in second row) played for five different major league teams between 1913 and 1931. He played on three different World Series winning teams.

The Twin Village Post 463 VFW building on the south side of Litchfield Street between Meridian and Preston Streets was originally constructed and occupied by the IOOF (Independent Order of Odd Fellows) Temple from 1926 until 1945, when it was acquired by the VFW Post. The group of veterans occupied the building through early 2013, when the post was disbanded.

The Polish Depew Club, a social organization, is composed of the various societies affiliated with St. Augustine's Church and serves the Polish community on the south side of the village. The clubhouse on Gould Avenue was constructed and opened in 1927. An addition housing eight bowling alleys was added in the early 1950s. The building currently houses God's New Covenant Church.

The Depew-Lancaster Boys and Girls Club on Preston Street between Terrace Boulevard and Litchfield Street housed the Eagles Aerie, which vacated the building in the early 1930s. In 1936, school superintendent George Crego saw the need for a place for youth to assemble. With the assistance of faculty and prominent local citizens, the Depew Boys Club was organized in 1937. It was destroyed by fire in January 2013.

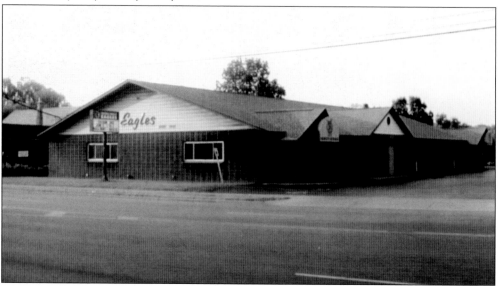

The Fraternal Order of Eagles Aerie 2692 clubhouse has been located at 4569 Broadway at Borden Road since 1977. The original aerie disbanded during the early 1940s as members went off to fight in World War II. In 1947, the order was rechartered and located at what is now the Pub Restaurant on Broadway until 1977. Their motto is "People Helping People."

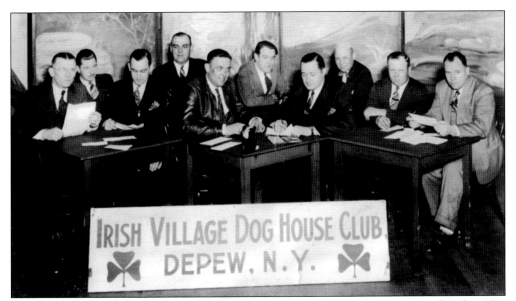

The Irish Village Dog House Club was a men's social club in the late 1940s and early 1950s composed of local sportsmen and businessmen who met at Garry's Irish Village Pub, which occupied the former bank building at Transit Road and Walden Avenue. Seated at the far left is John Mokan, a former big league baseball player with the Pittsburgh Pirates and Philadelphia Phillies between 1921 and 1927.

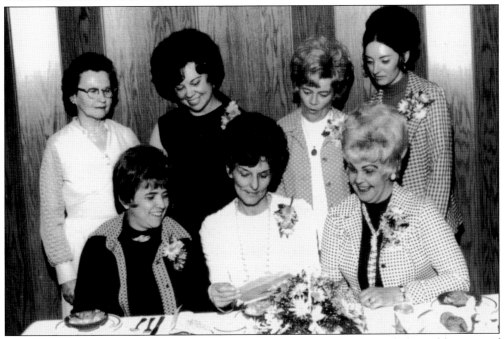

The Depew Women's Club was organized in the mid-1940s as a social and charitable group of women who were residents of the village. The 1974 officers of the organization included, from left to right, (first row) Geraldine Arber (treasurer), Dorothy Schuler (president), and Mildred Bauer (vice president); (second row) Inez Keller (installing officer), Alberta Pempsell (corresponding secretary), Kitty Brandenburger (auditor), and Shirley Fusani (recording secretary).

The Depew Recreation Department provides various programs, including bingo, arts and crafts, and cards for senior citizens. In 1973, the village provided a meeting place in the remodeled former Gould Avenue Firehouse. Today, the senior citizens' program is held in the rear of the village hall. Walter Jeziorski lines up his pool shot as, from left to right, Frank Suplicki, Larry Schrabas, and Joseph Zwolinski watch.

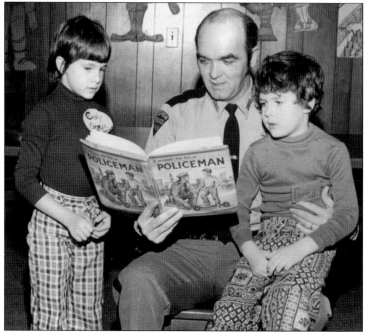

The Depew Recreation Department, in conjunction with the Depew Police Department and the library, took part in a story hour for youngsters. Patrolman Gordon Willis reads *I Want to be a Policeman* to youngsters enrolled in the program. The program ran from October to April on Saturdays and proved to be a very popular event.

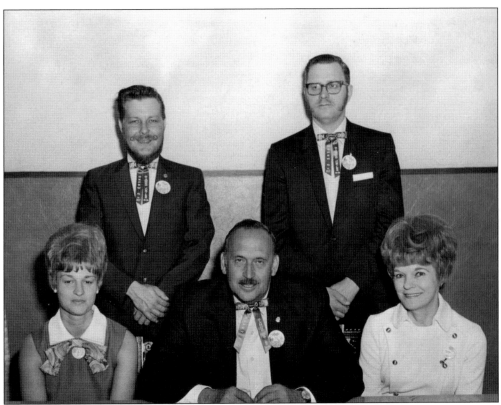

In early January 1969, John Schuler, a longtime local businessman and firefighter, was named as general chairman of the village of Depew's Diamond Jubilee celebration. Members of the executive committee are, from left to right, (first row) Mary Ann Schulz, John Schuler, and Sophie Wargala; (second row) Joseph Dombrowski and Arthur J. Domino.

The official seal of the Village of Depew was proposed by Lewis R. Wenzka, chief of police, and adopted by the village fathers during the Diamond Jubilee celebration in July 1969. The rendering of the design was created by a local artist, Joanne Earley. The steam locomotive represents the railroad industry, which spurred the growth of the village. The symbolic fire hose represents the need for fire protection.

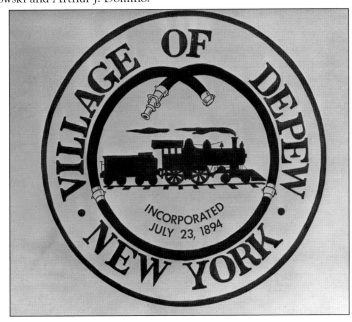

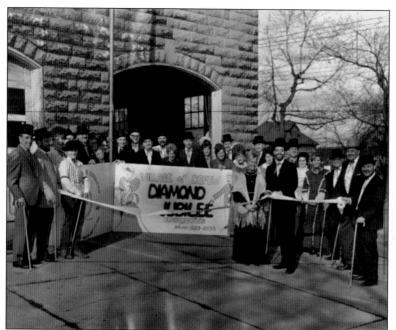

On Sunday, March 9, 1969, Depew mayor Joseph Natale, assisted by Dorothy Natale, cut the ribbon to officially open the village's Diamond Jubilee headquarters as village officials and committee members look on. The ceremony took place in front of the former Gould Avenue Firehouse at Penora Street and Gould Avenue.

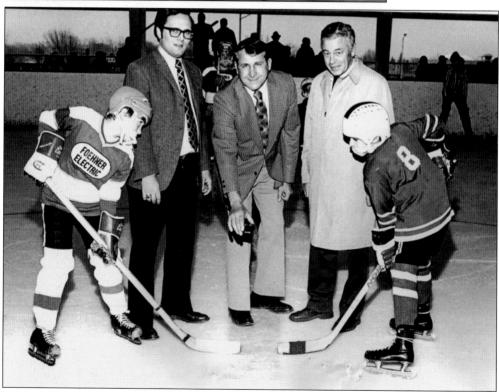

Village of Depew mayor John Potter prepares to drop the ceremonial puck in the newly opened ice rink as recreation director Donald Kwak (left) looks on; the others are unidentified. The facility currently runs skating lessons, holds open skates, houses youth hockey leagues, and has hosted international hockey tournaments for both young and old.

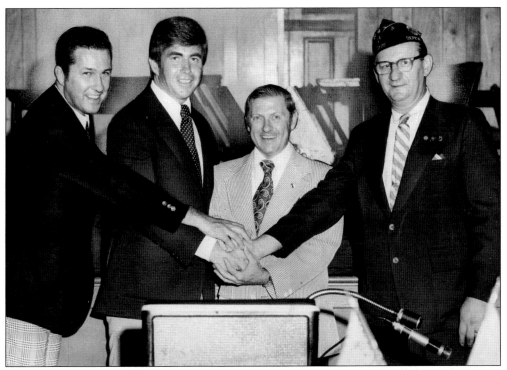

In 1919, the American Legion was formed in Paris, France, and it is the world's largest veterans organization. Depew Post 1528 was organized in 1946. On August 3, 1974, the members celebrated the 55th anniversary of the organization at their installation of officers banquet. From left to right, state senator Dale Volker; Congressman Jack Kemp; and Lt. Col. William Cybulski, West Point liaison officer of western New York, posed with post commander Richard S. Zmozynski.

The Amvets received their charter in 1946. The Amvets Post 14, located at 2147 Broadway, was named in honor of Richard A. "Buddy" Knaus, the first man from Cheektowaga killed in Vietnam, who died on December 26, 1966. Their building had been used as a New York State Unemployment Office and later a health facility before being acquired by the Amvets for their clubhouse in 1976.

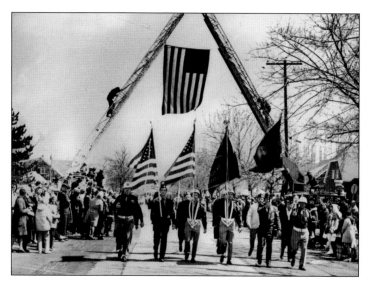

Twin Village Post 463 VFW Color Guard leads the Erie County Loyalty Day Parade down Terrace Boulevard under the American flag supported by the aerial ladder from the Depew and Lancaster Fire Departments. The parade on May 2, 1971, was sponsored by the Erie County Council Veterans of Foreign Wars, and it attracted an estimated 10,000 spectators and 2,700 marchers.

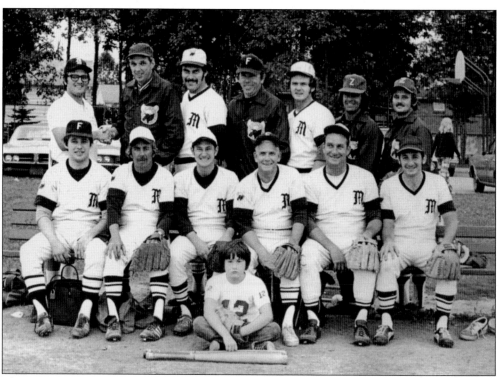

The Depew Recreation Department's various programs included an adult slow-pitch league. The league is made up of players who reside in the village of Depew or the Lancaster School District. Pictured here, the 1973 league championship team, the Lancaster Moose, with team manager Robert O'Neil, is being congratulated by recreation director Donald Kwak.

Besides the recreational swim program, a learn to swim program has been conducted at the village swimming and wading pool since its opening. College students, under the direction of the recreation director, serve as coaches and lifeguards. Pictured here in 1978, swimming instructor Melinda Hall teaches a young Angela Andrejewski to float.

Depew's Diamond Jubilee celebration was kicked off on Sunday, April 6, 1979, with an Easter Parade. Depew residents in their Easter finery are shown strolling down Terrace Boulevard to the Veterans Park in 1969. The day was topped off by a Gala Jubilee Ball at Hearthstone Manor.

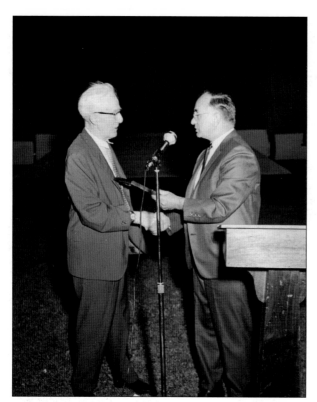

Prior to the opening performance of the spectacular pageant *A Song of Man* during the Diamond Jubilee week, Dr. Martin Tyrrell, a practicing physician in the village since 1924, was presented with a plaque commending him for "untiring, selfless, and exceptional long-standing service to God, Country, and community." Dr. Tyrrell, left, receives the plaque from Depew school superintendent Marco Guerra, right.

Depew celebrated its centennial over a two-week period in July 1994, which included a kick-off dance, children's activities, a carnival, a Taste of Depew, art exhibits, a parade, and many other activities. Chairman Geraldine Arber, assisted by her committee, Don Jakubowski, Judy Michaels, and Conrad Wienckowski, planned a full schedule of activities that attracted crowds from far and wide.

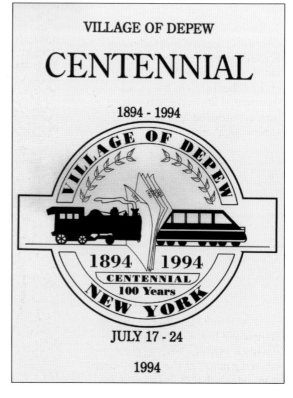

VILLAGE OF DEPEW

CENTENNIAL

1894 - 1994

JULY 17 - 24

1994

One of the many floats in the parade featured Big Korney and his gang of bootleggers who operated in Depew. Complete with attractive young flappers, it recalled a colorful era not only in the village of Depew, but throughout the country. Many of the other floats in the parade represented life in the village and were constructed by many of the various local organizations.

Depew High School was the site of a time walk, which featured many reenactors from America's past. Ray Prestine, who organized the event, is standing here posed in his French and Indian War costume. His uncle Arthur Prestine, the oldest surviving mayor of the village, served as grand marshal of the parade.

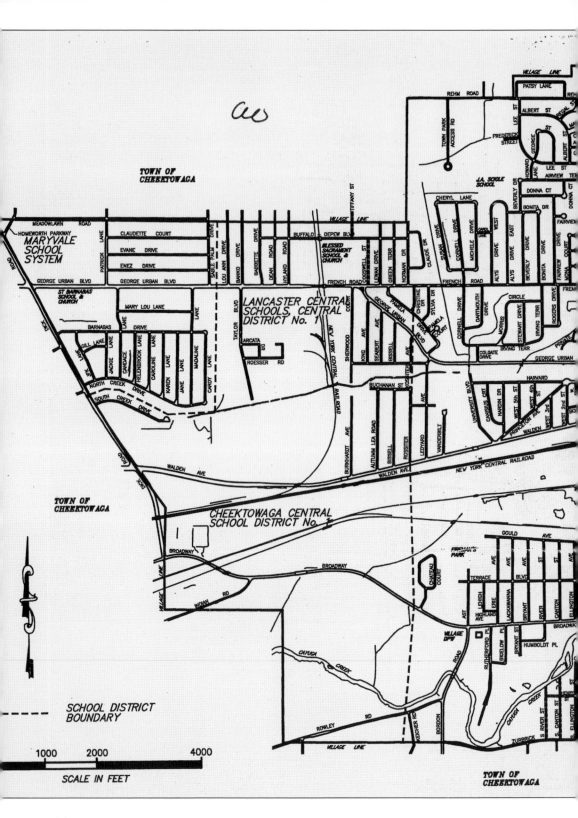

SCHOOL DISTRICT
BOUNDARY

1000 2000 4000
SCALE IN FEET

126

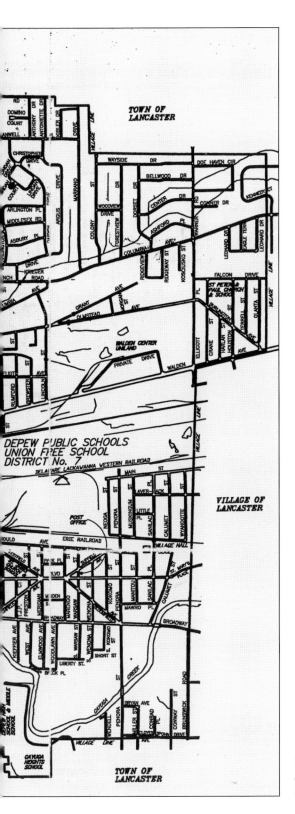

Pictured here is a map of the village of Depew, the town of Cheektowaga, and the town of Lancaster.

DISCOVER THOUSANDS OF LOCAL HISTORY BOOKS
FEATURING MILLIONS OF VINTAGE IMAGES

Arcadia Publishing, the leading local history publisher in the United States, is committed to making history accessible and meaningful through publishing books that celebrate and preserve the heritage of America's people and places.

Find more books like this at
www.arcadiapublishing.com

Search for your hometown history, your old stomping grounds, and even your favorite sports team.

Consistent with our mission to preserve history on a local level, this book was printed in South Carolina on American-made paper and manufactured entirely in the United States. Products carrying the accredited Forest Stewardship Council (FSC) label are printed on 100 percent FSC-certified paper.

MADE IN THE
USA